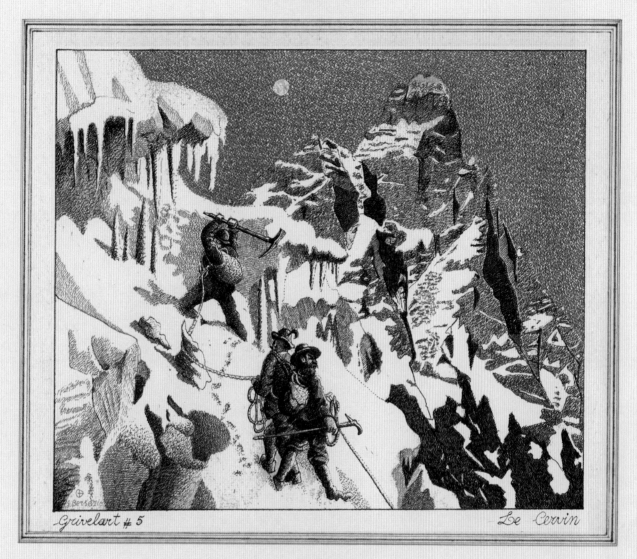

Grivelart #5 Le Cervin

In direct response to the demands of both mountains and mountaineers

the Grivels made modifications to the normal workman's pick axe.

Thus, without a true inventor, the "piolet" was born.

The heads of these ice axes were hand-forged of the best quality steel available, heat-treated to provide

greater resistance and the slag was removed by tumbling them in a water-driven revolving barrel.

The heads were then polished and fitted onto solid ash handles.

The demands of the mountains have evolved somewhat over the past hundred years and modern ice

axes reflect these changes, but the tool's basic premise remains the same.

GRIVEL'S CATALOGUE - 1999

GRIVEL srl - 11013 Courmayeur (AO) - Italy
P.O. box 76 - P.IVA 00139110076 - Phone: +39 0165 843714 - Fax: +39 0165 844800
e-mail: grivelart@grivel.com - htt://www.grivel.com

m i l l e n n i u m

GRIVELART • P.O. Box 76 • 11013 Courmayeur (AO) • ITALY
Phone: +39 0165 843714 • Fax: +39 0165 844800 • e-mail: grivelart@grivel.com

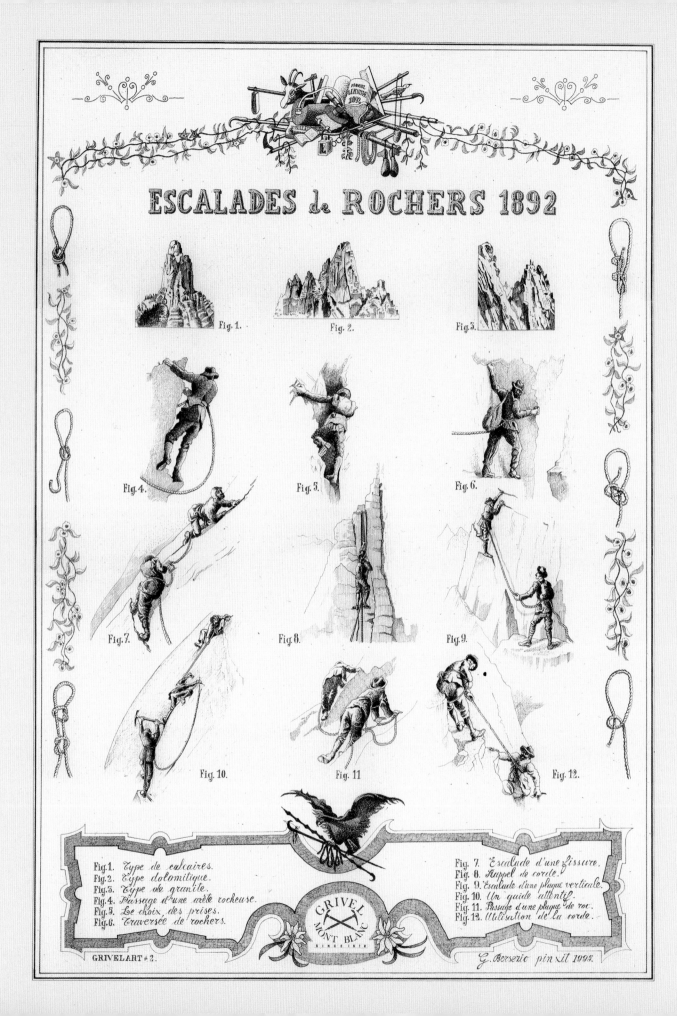

ESCALADES de ROCHERS 1892

GRIVEL MONT BLANC SINCE 1818

GRIVELART № 2.

G. Berserio pinxit 1992.

A tribute to the mountains, a statement revealing our passion for them.

These are the motivations which underlie the project to be revealed in the following pages.

As the Third Millennium approaches we wanted to create a global dialogue centered on the mountains. What better medium than photography?

Photographs don't need to be translated as everyone can interpret them in their own way, personal emotions can flow as they please, feelings and sensations develop according to the individual state of mind.

A series of images, by the world's best photographers, offers us a journey through twelve different realities, each illustrating the mountains' multiple aspects.

The images are bound together by essential, no-frills graphics... As if inspired by "Zen" allowing every photograph the maximum respect.

It is a celebration of the spirit, manifested through the photographers' finest achievements, these silent and modest mountaineers who, undertaking difficult assignments, accept the risks involved, so as to witness and make the achievements of others credible.

This undertaking has an underlying thread, the love, which unites all those who are dedicated to the same life-long passion: the mountains. BETTA E GIOACHINO

We would like to continue
this dialogue with the mountains
through your images,
so if anybody
is interested please get in touch.

Grivelart - Betta Gobbi - P.O. Box 76
- 11013 Courmayeur (AO) - Italy.
Phone: 0039.0165.843714
Fax: 0039.0165.844800
Email: grivelart@grivel.com

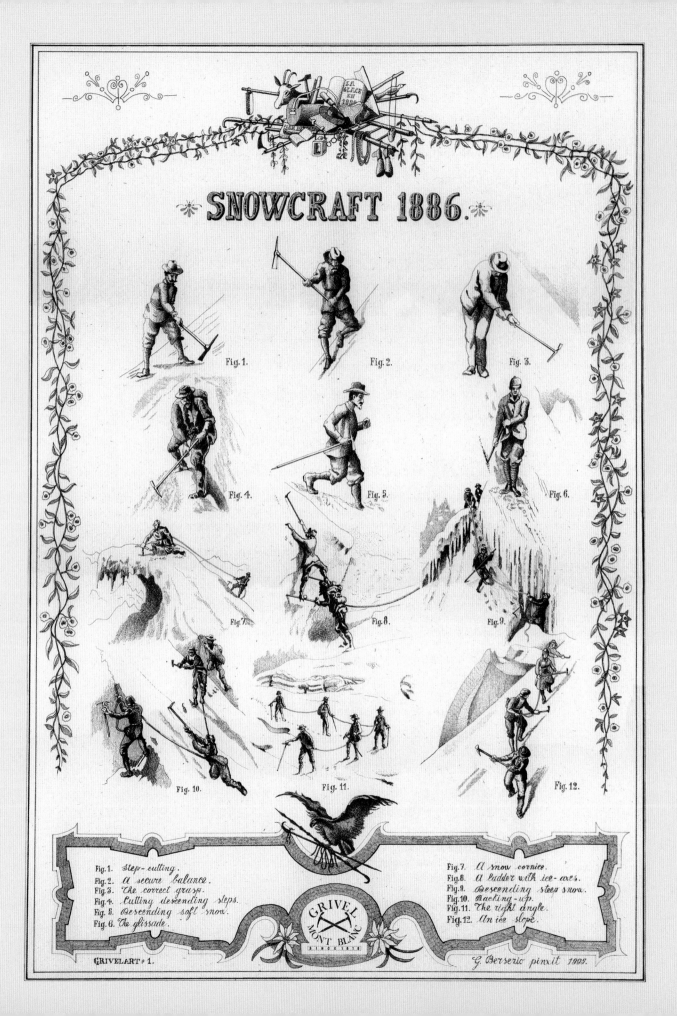

SNOWCRAFT 1886.

Fig. 1.
Fig. 2.
Fig. 3.
Fig. 4.
Fig. 5.
Fig. 6.
Fig. 7.
Fig. 8.
Fig. 9.
Fig. 10.
Fig. 11.
Fig. 12.

Fig. 1. Step-cutting.
Fig. 2. A secure balance.
Fig. 3. The correct grasp.
Fig. 4. Cutting descending steps.
Fig. 5. Descending soft snow.
Fig. 6. The glissade.

Fig. 7. A snow cornice.
Fig. 8. A ladder with ice-axes.
Fig. 9. Descending steep snow.
Fig. 10. Backing-up.
Fig. 11. The right angle.
Fig. 12. An ice slope.

GRIVEL MONT BLANC

GRIVELART # 1.

G. Berserio pinxit 1995.

CONTENTS

peaks
cime
cimes
gipfel
cimas

PEAKS

CERRO TORRE,
ARGENTINA,
ph. Max Berger, 1995.

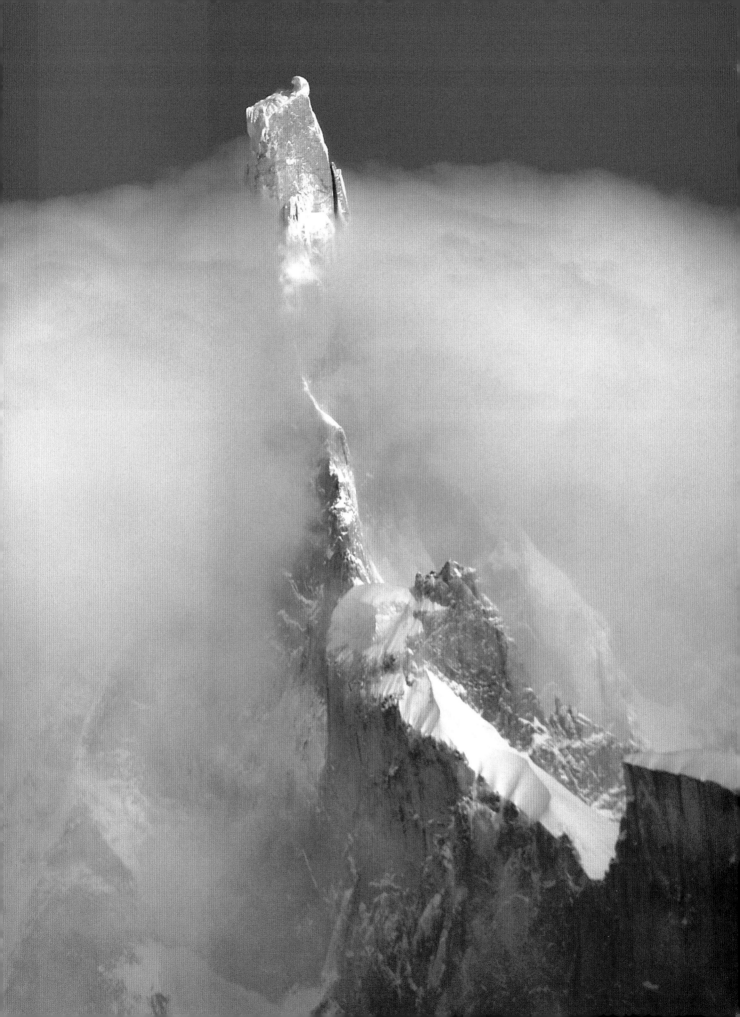

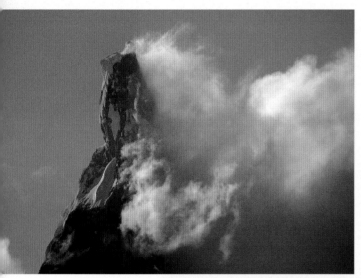

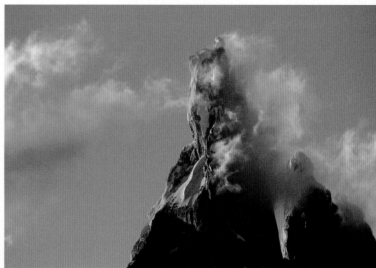

CERRO TORRE,
ARGENTINA,
ph. Max Berger, 1995.

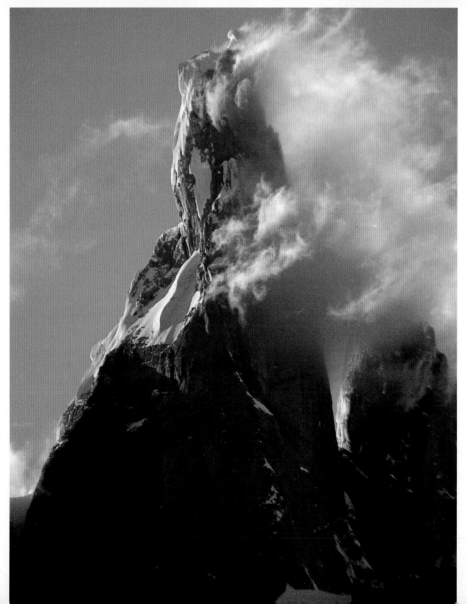

NAO YIU YAI,
CHINA,
ph. Marco Milani, 1996.

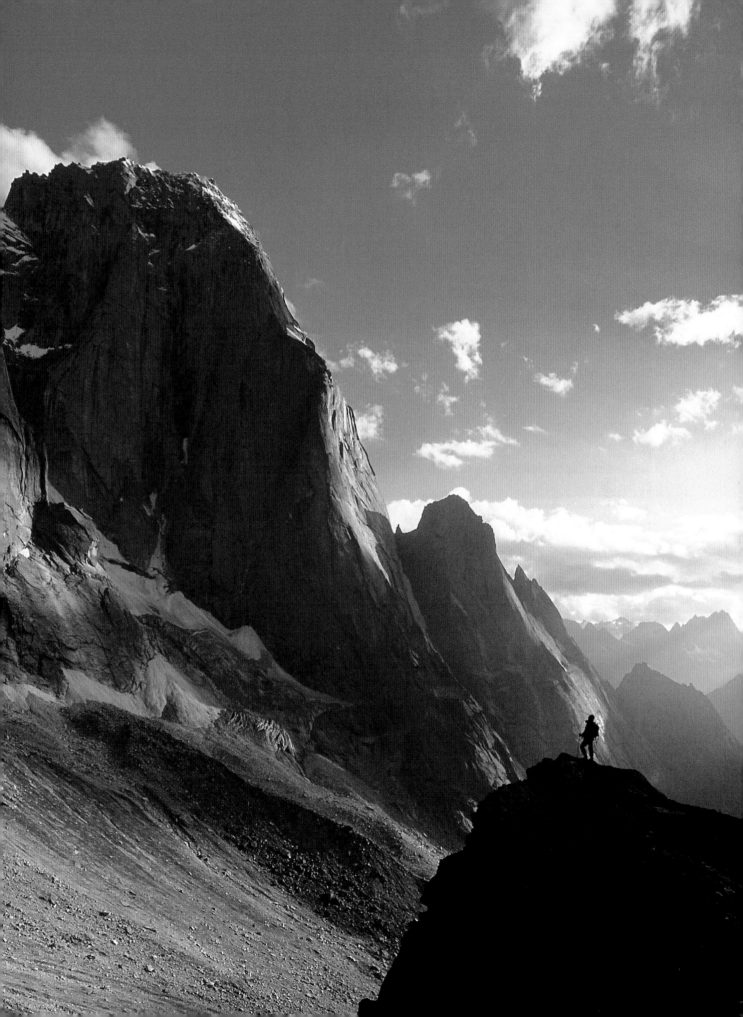

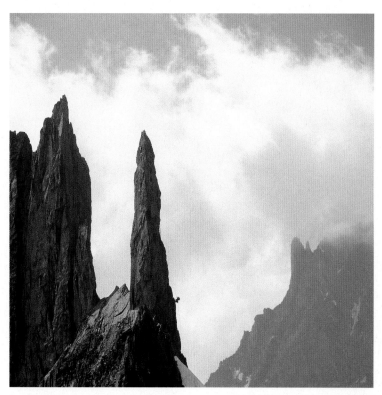

PERE ETERNEL
(winter time),
Mont Blanc, ITALY,
ph. Renzino Cosson, 1994.

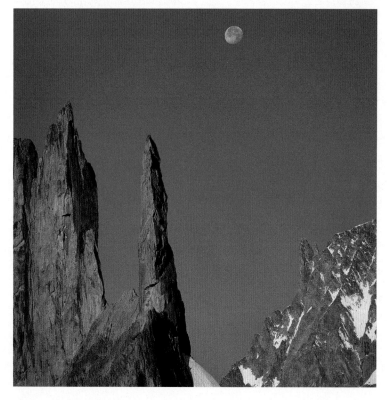

PERE ETERNEL
(summer time),
Mont Blanc, ITALY,
ph. Renzino Cosson, 1994.

MT. KAILAS,
TIBET,
ph. Galen Rowell, 1987.

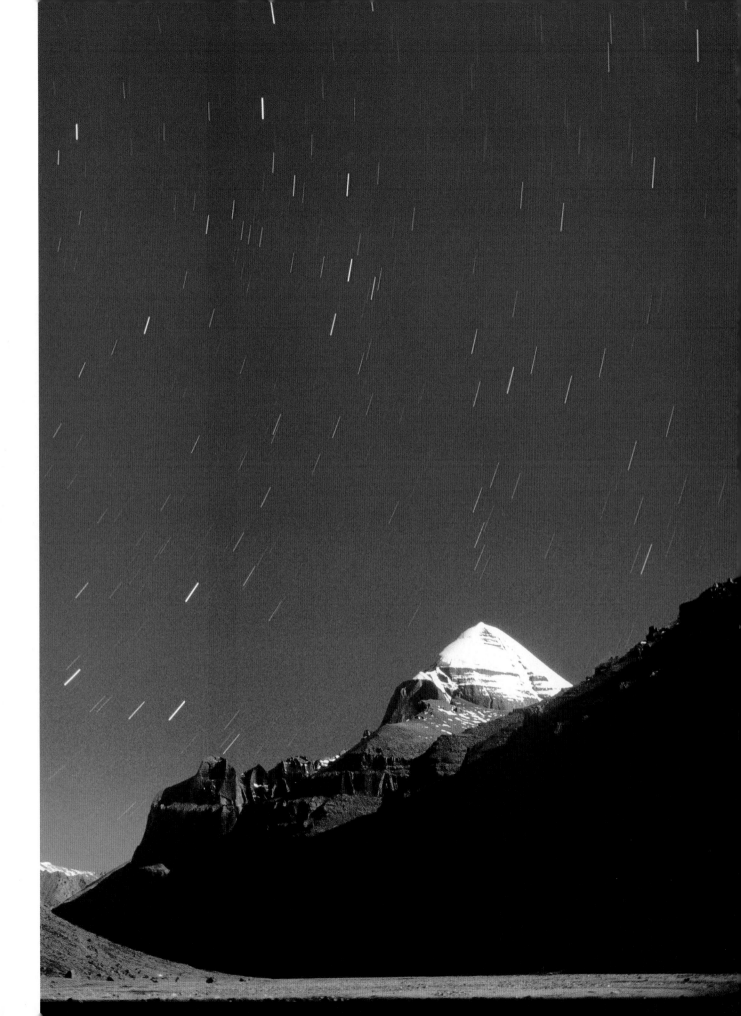

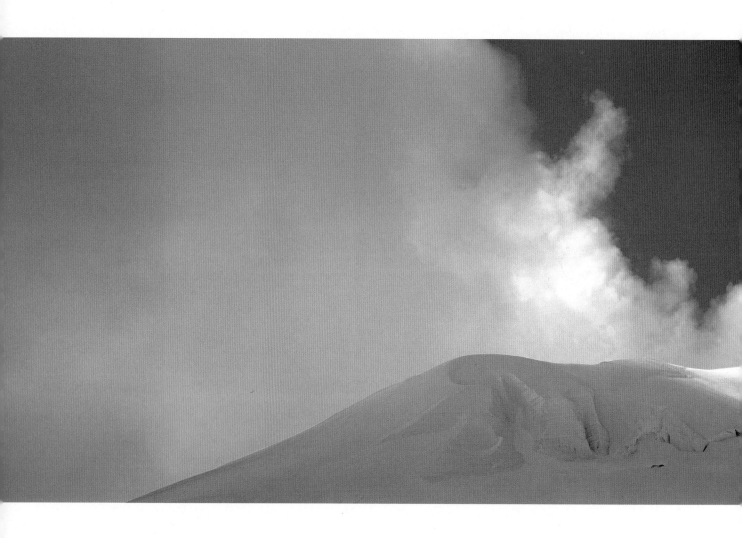

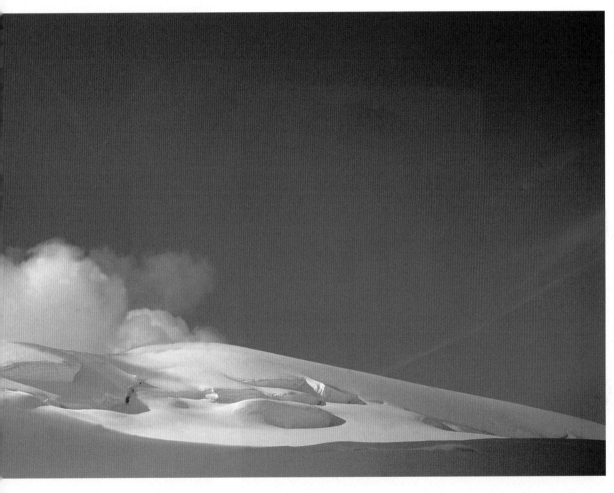

PUNTA PARROT,
Mt. Rosa, ITALY,
ph. Davide Camisasca,
1993.

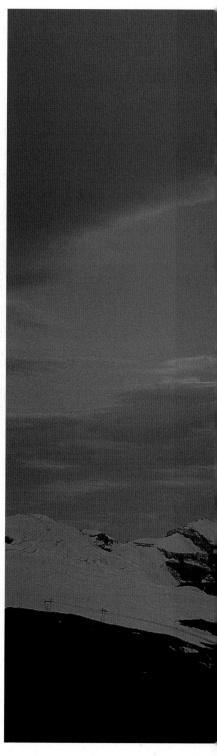

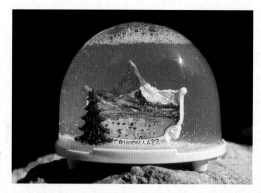

MATTERHORN
SOUVENIR,
ph. Gerhard Heidorn, 1989.

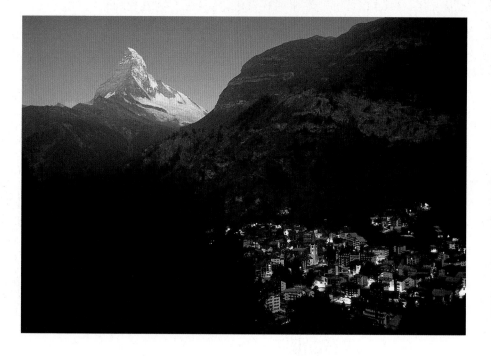

MATTERHORN,
SWITZERLAND,
ph. Gerhard Heidorn, 1989.

MATTERHORN,
SWITZERLAND,
ph. Davide Camisasca, 1990.

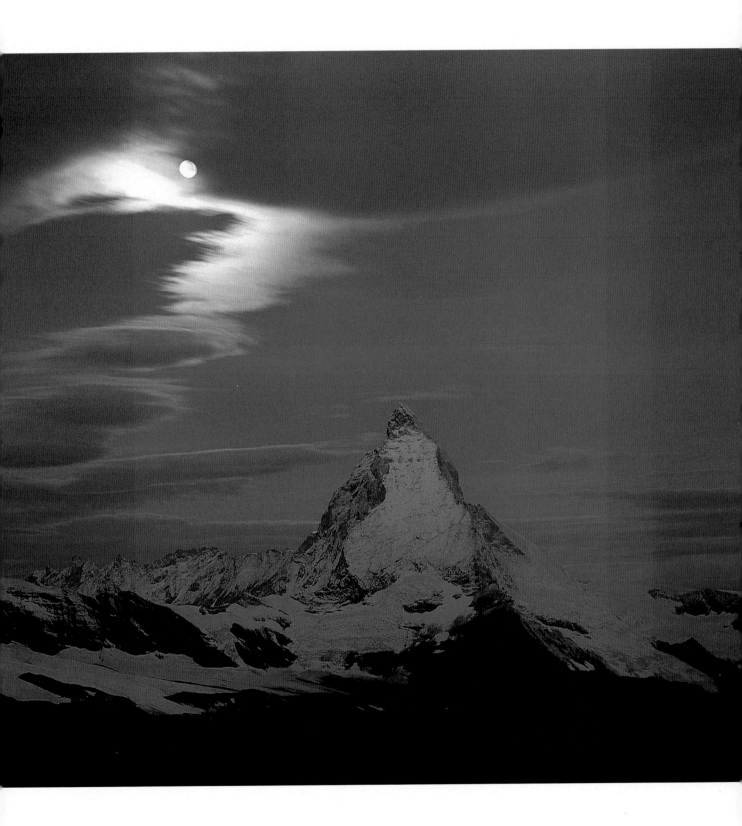

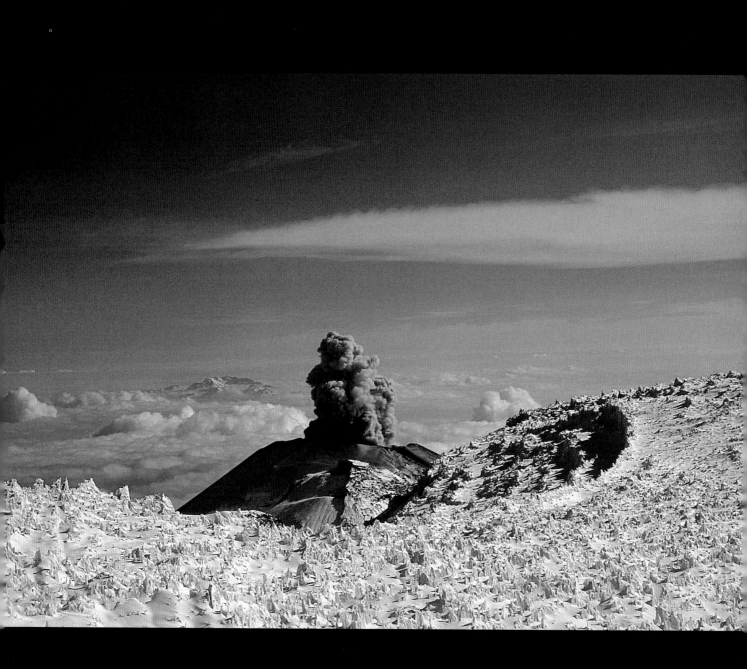

SACANBAJA VOLCANO,
PERU,
ph. Patrick Wagnon, 1995.

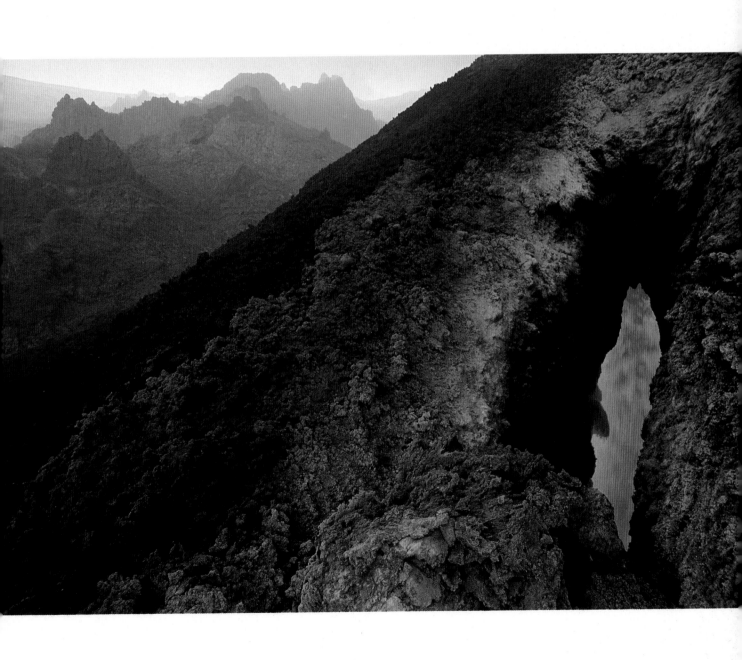

ETNA VOLCANO,
ITALY,
ph. Gianluca Boetti, 1992.

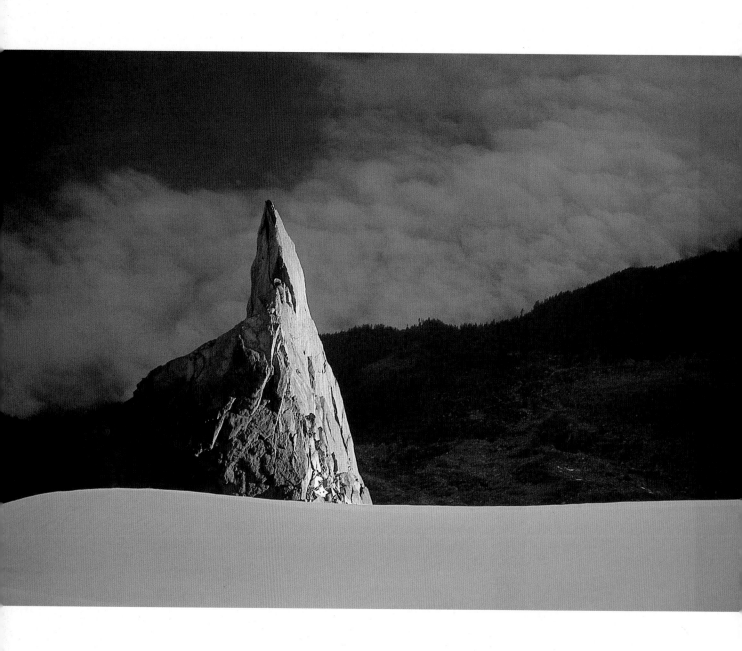

DEUX AIGLES,
France,
ph. Claude Gardien, 1994.

KHUMBU VALLEY,
Nepal,
ph. Xavier Murillo, 1989.

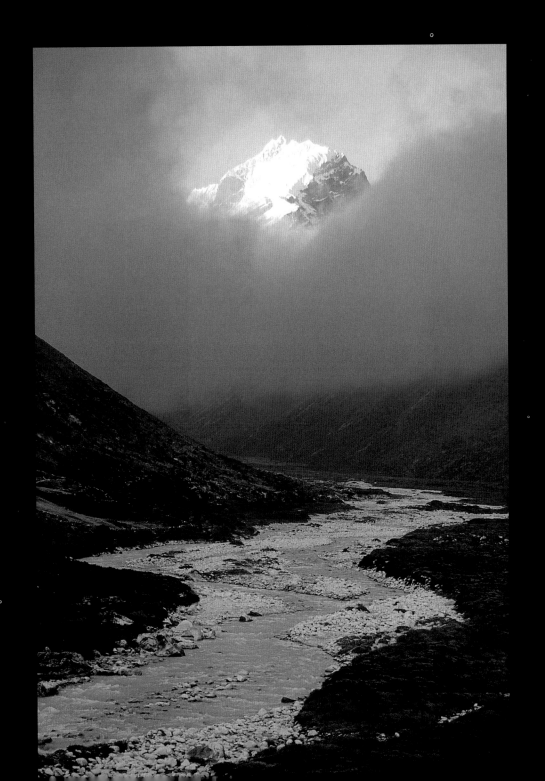

rock
roccia
rocher
fels
roca

ARCHES
NATIONAL PARK,
USA,
ph. Gérard Kosicki, 1985.

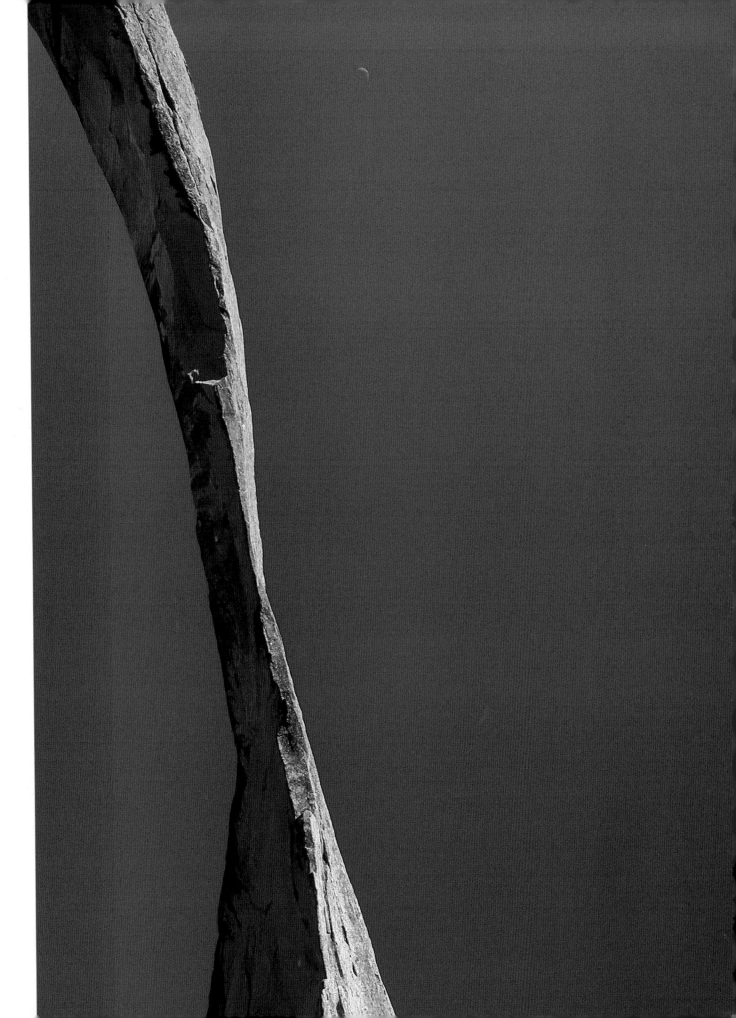

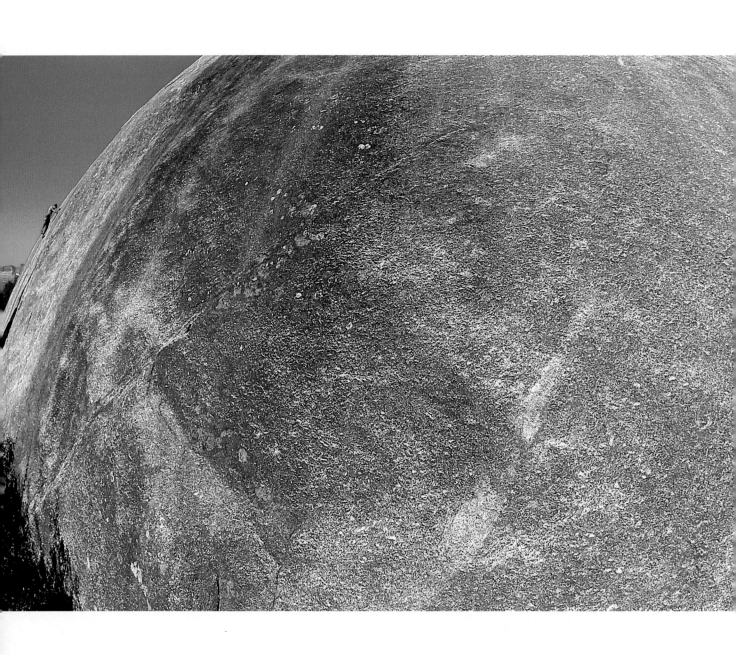

MELLO VALLEY,
ITALY,
ph. *Andrea Gallo, 1997.*

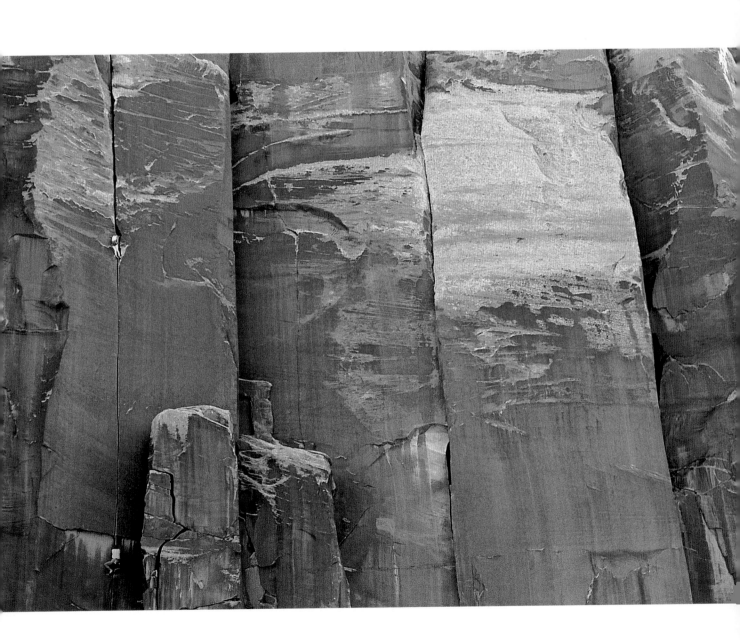

INDIAN CREEK CANYON,
USA,
ph. Gérard Kosicki, 1985.

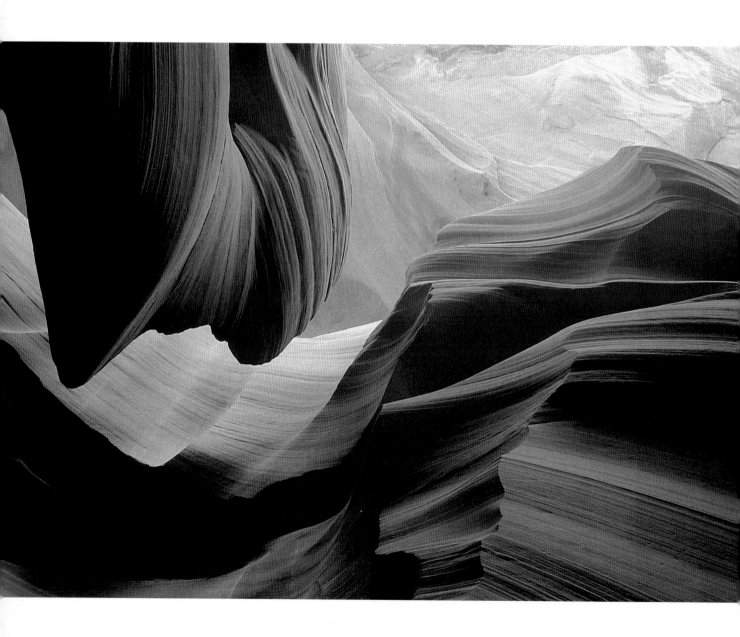

ANTELOPE CANYON,
USA,
ph. Heinz Zak, 1994.

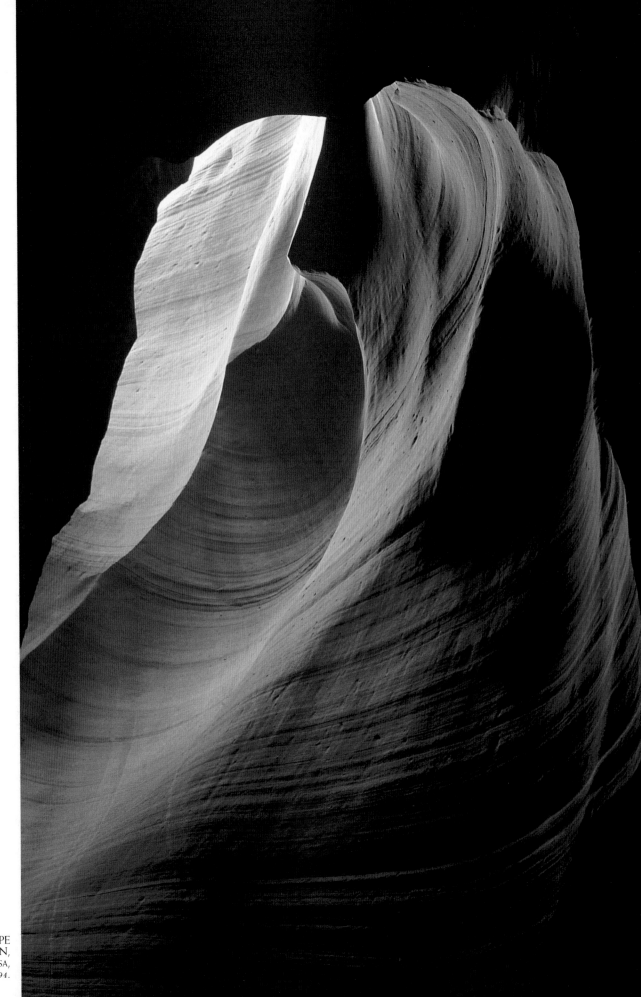

ANTELOPE
CANYON,
USA,
ph. Heinz Zak, 1994.

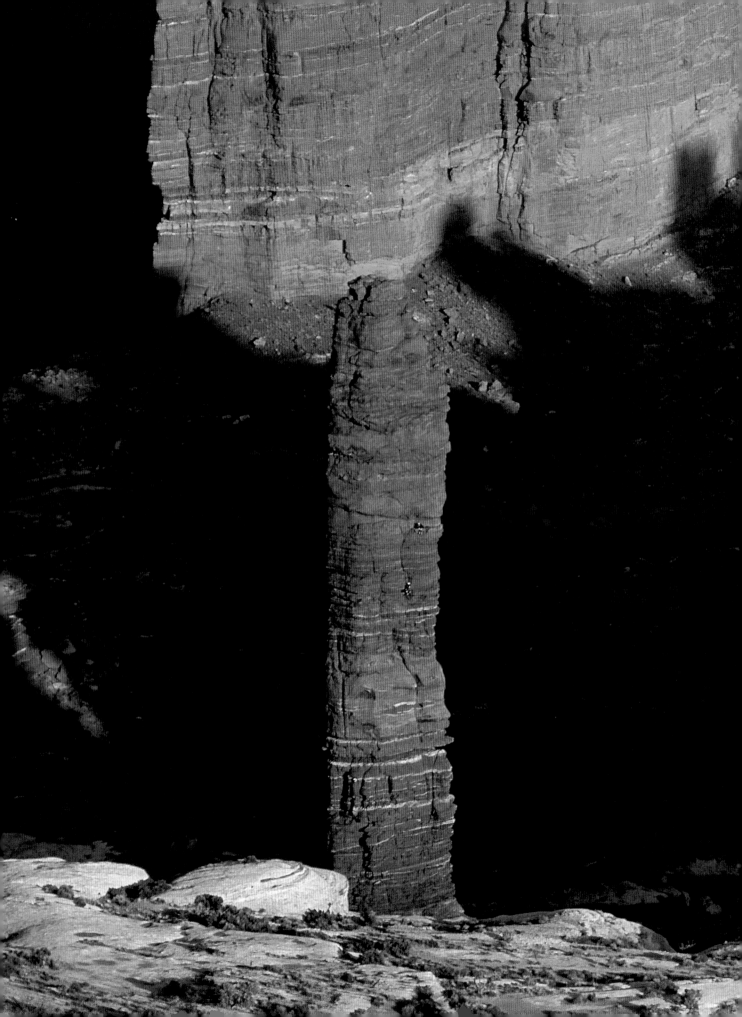

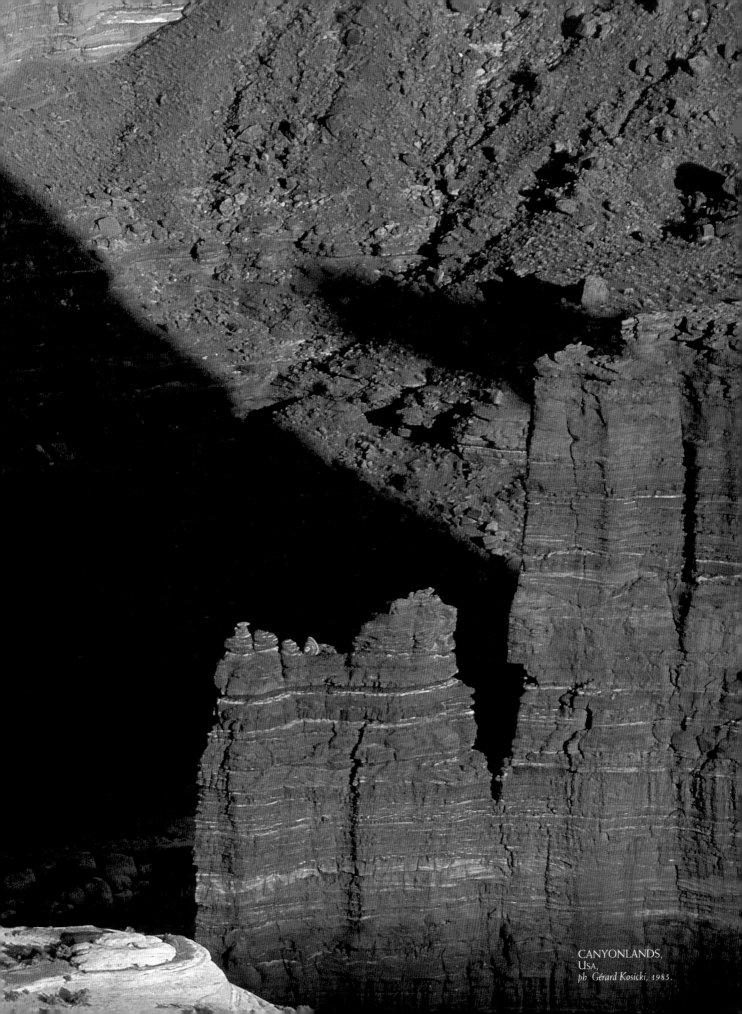

CANYONLANDS,
USA,
ph. Gérard Kosicki, 1985.

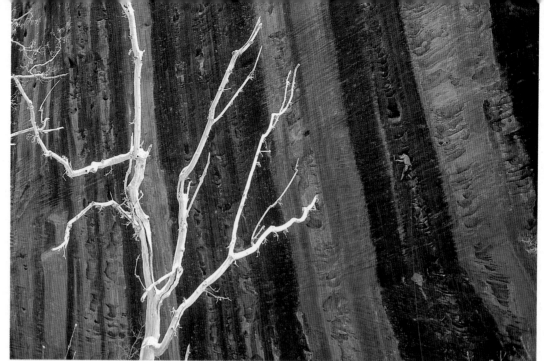

KOLOB
CANYON,
USA,
ph. Jim Thornburg,
1994.

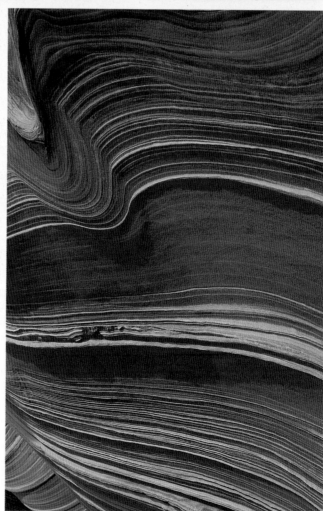

ROCK,
USA,
ph. Gérard Kosicki, 1986.

ROCK,
USA,
ph. Gérard Kosicki,
1986.

GRAND CANYON,
USA,
ph. Andrea Alborno,
1996.

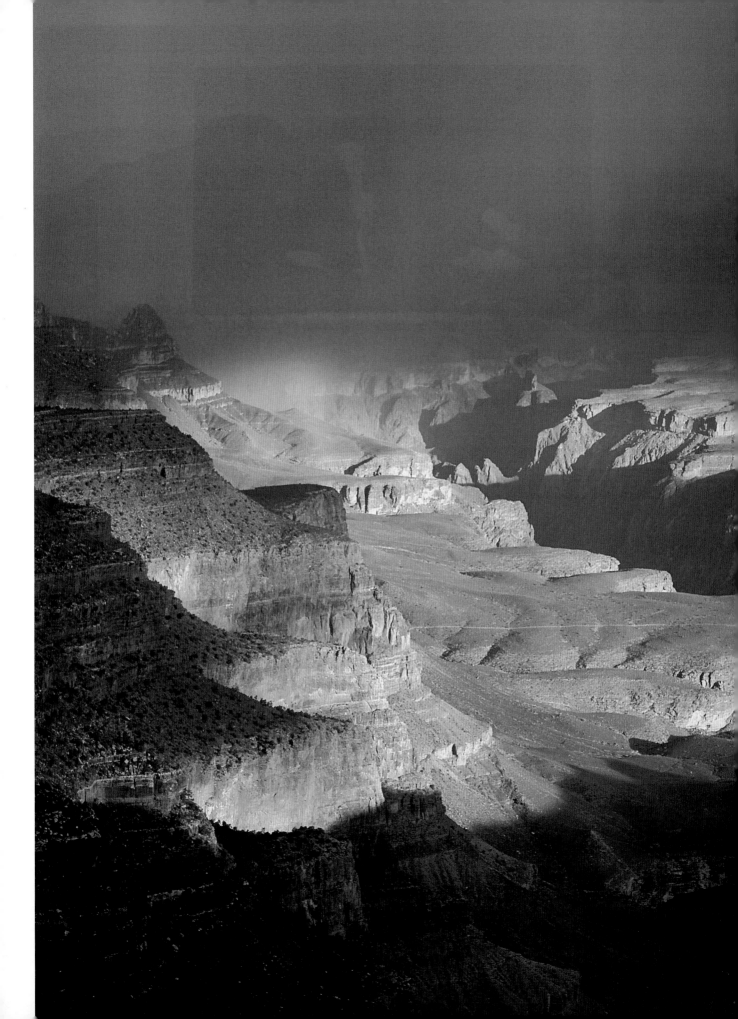

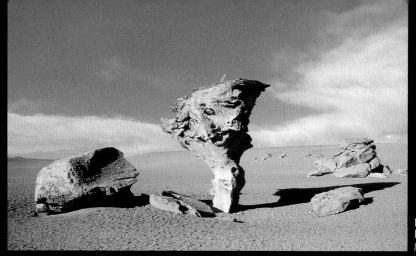

ROCK FLOWERS,
BOLIVIA,
ph. Patrick Wagnon, 1995.

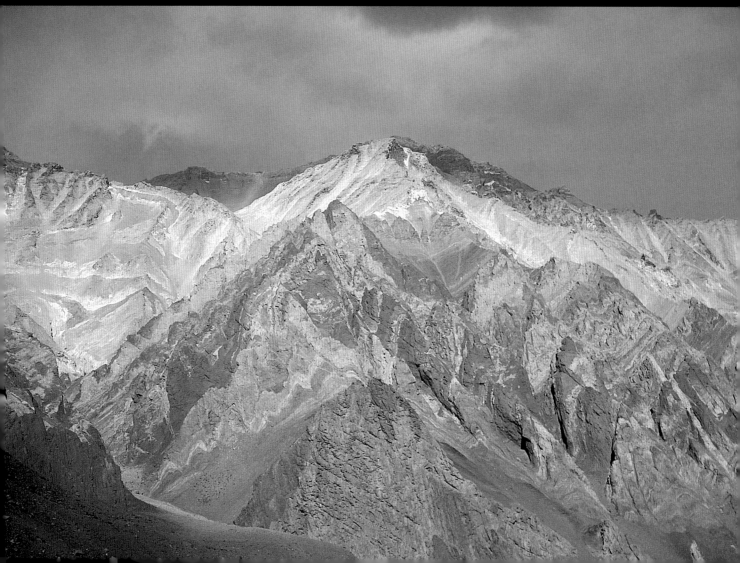

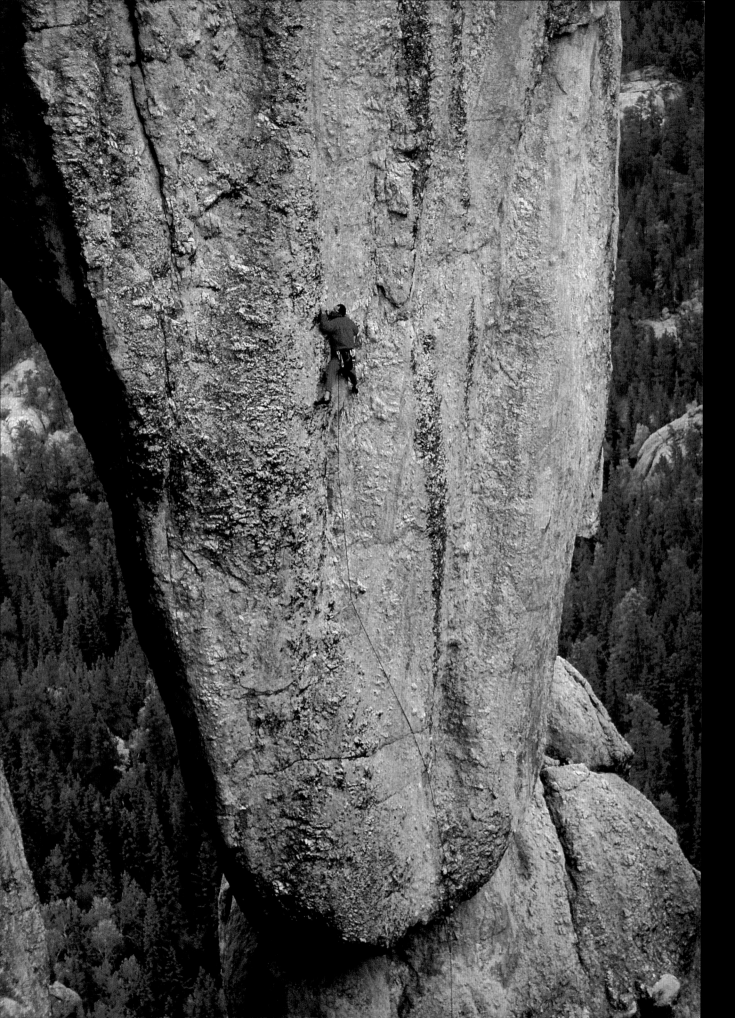

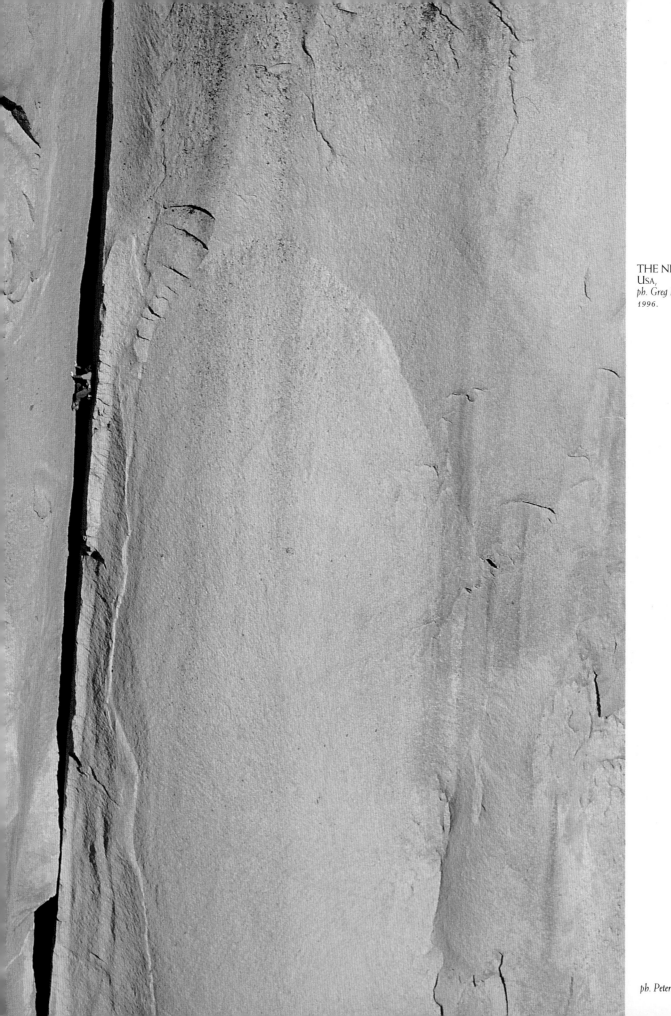

THE NEEDLES,
USA,
ph. Greg Epperson,
1996.

TOULON,
FRANCE,
ph. Peter Mathis, 1993.

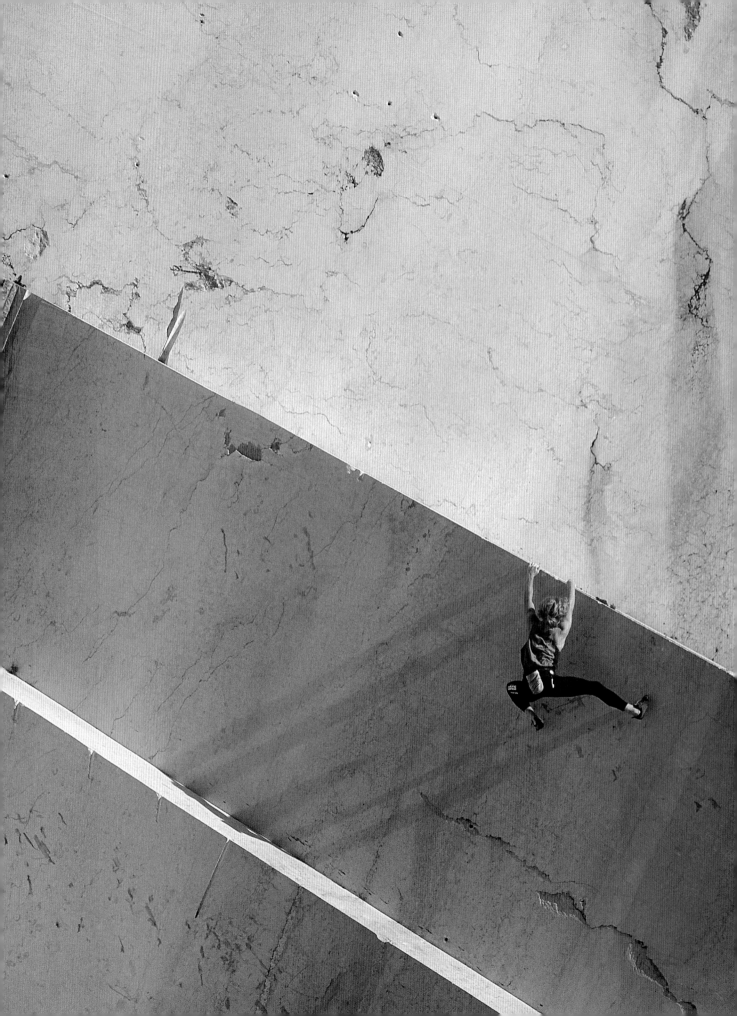

ice
ghiaccio
glace
eis
hielo

ICE

ICELAND,
ph. Nicholas Moulin, 1998.

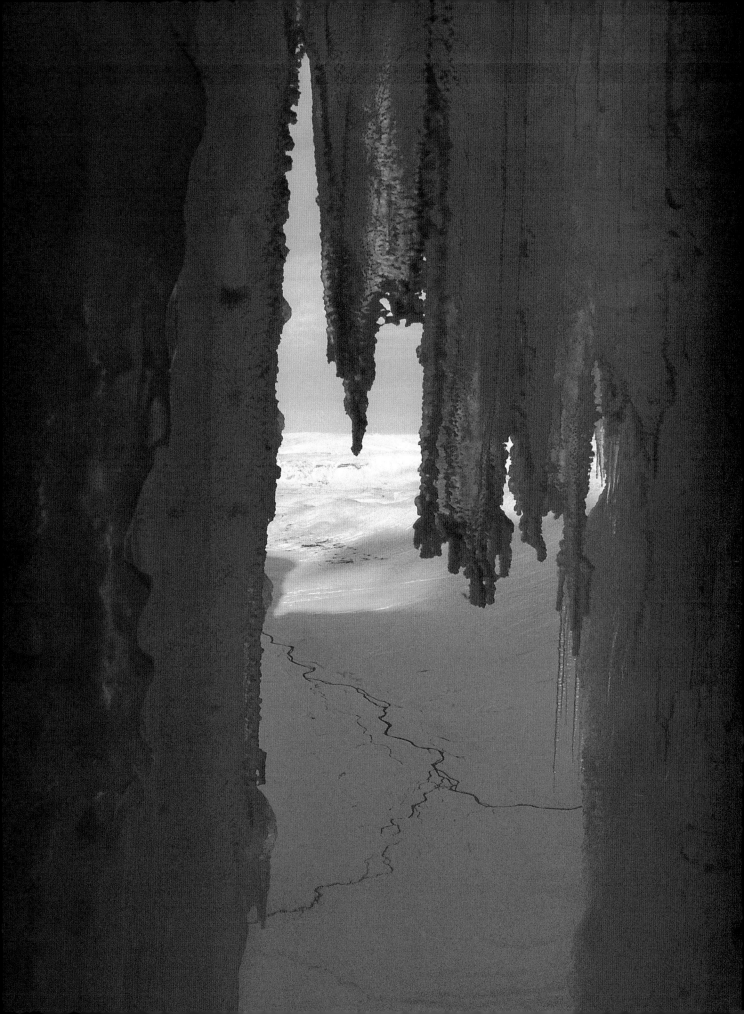

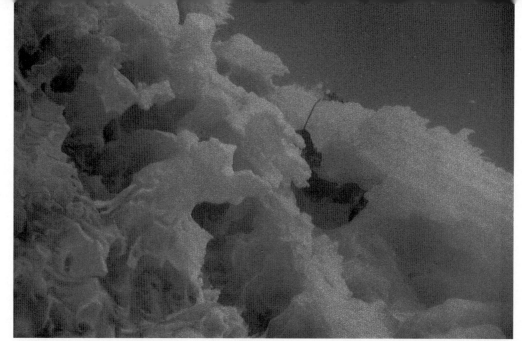

ICELAND,
*ph. Nicholas
Moulin,*
1998.

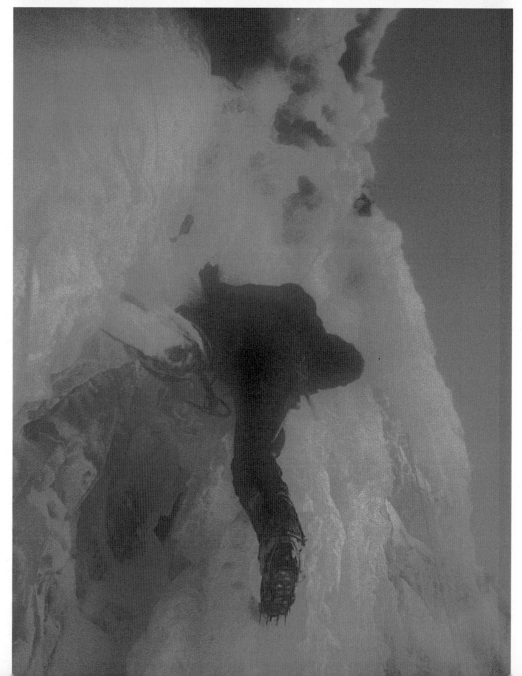

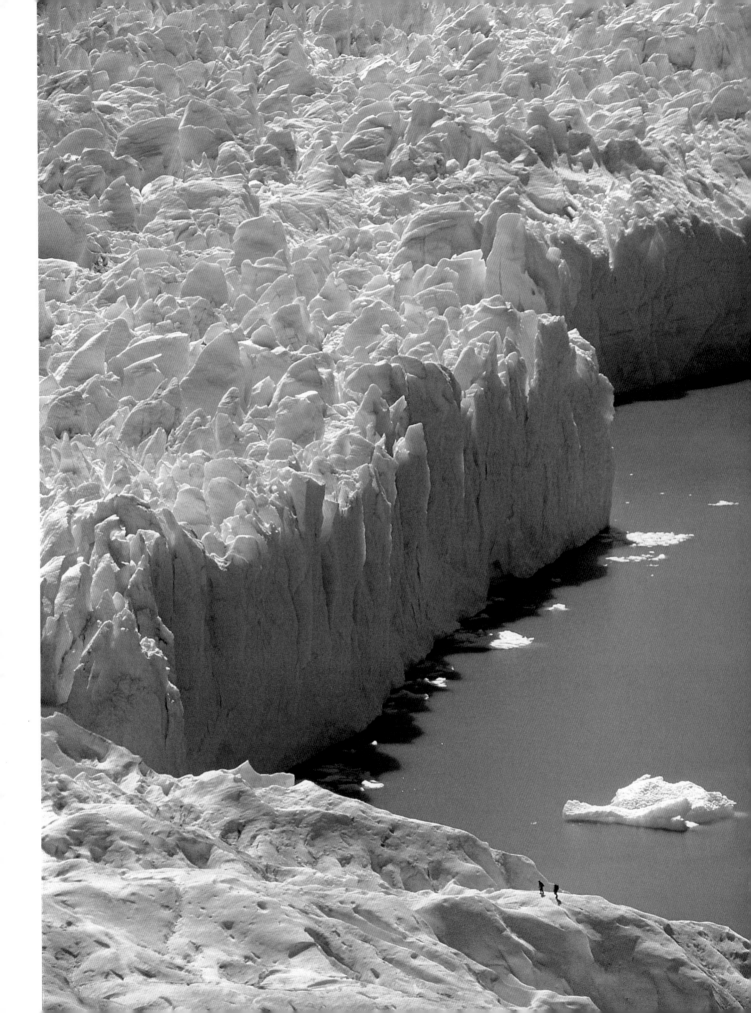

◀ PERITO MORENO
GLACIER,
ARGENTINA,
ph. Thomas Ulrich,
1996.

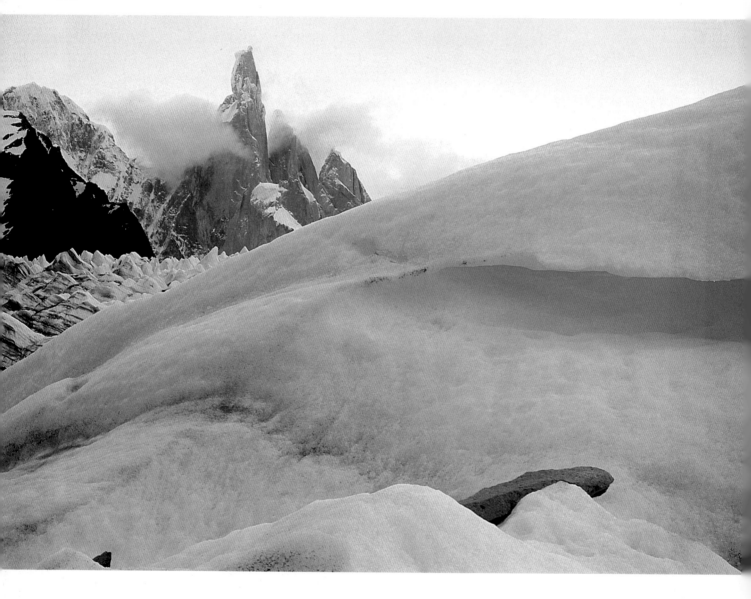

CERRO TORRE,
ARGENTINA,
ph. Uli Wiesmeier, 1998.

TRIOLET GLACIER,
Mont Blanc,
FRANCE,
ph. Gianluca Boetti, 1996.

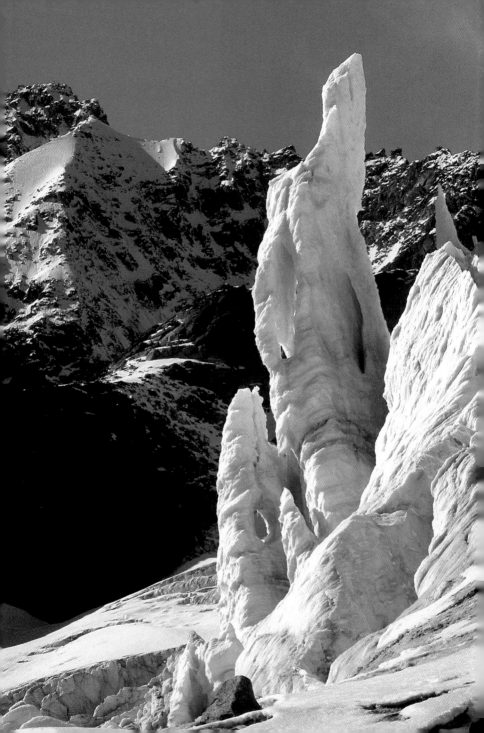

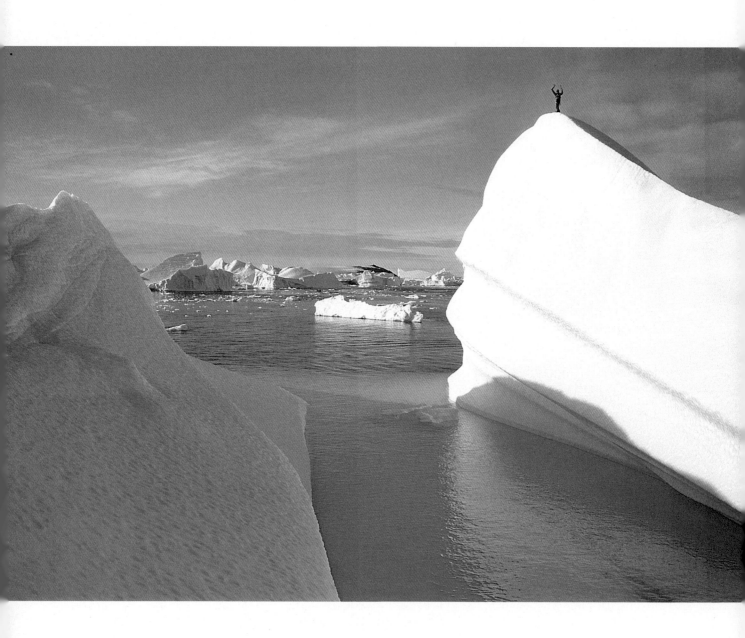

ICEBERG CEMETERY,
ANTARCTIC PENINSULA,
ph. Mark F. Twight, 1997.

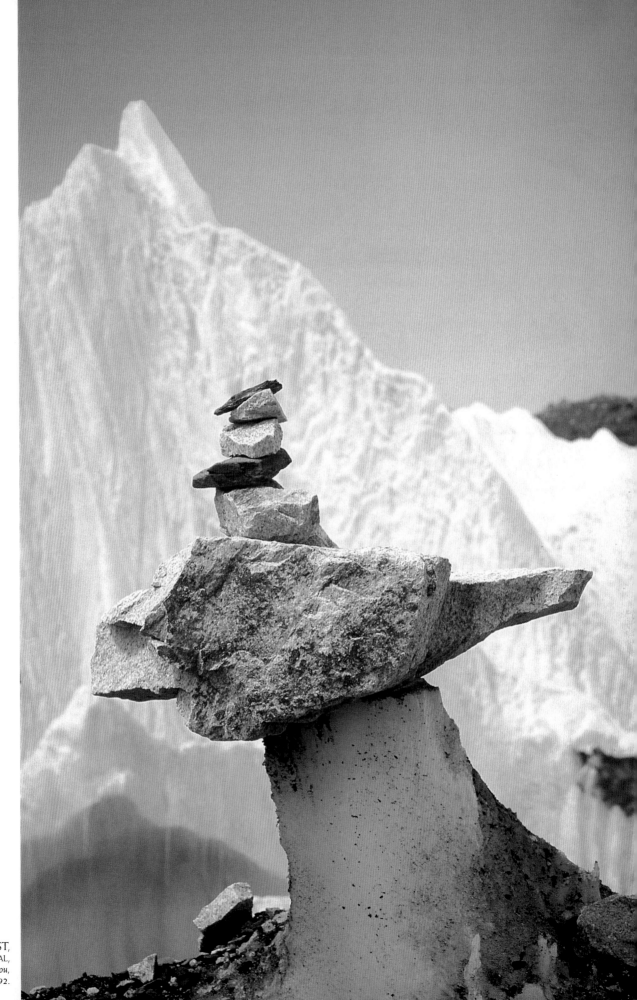

EVEREST,
NEPAL,
ph. Patrick Gabarrou,
1992.

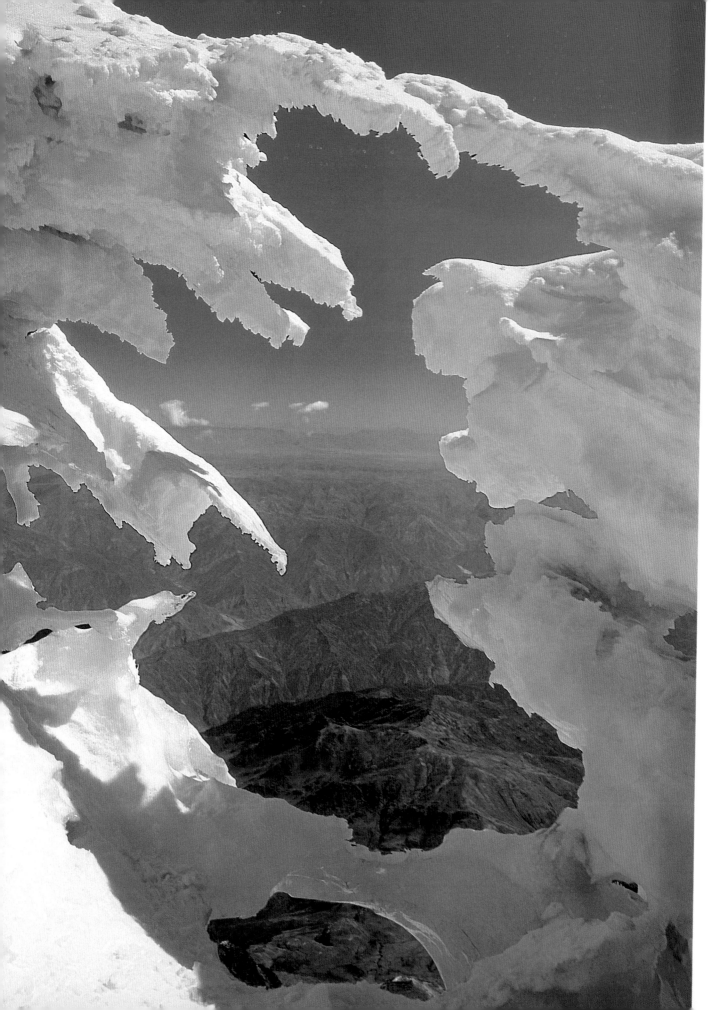

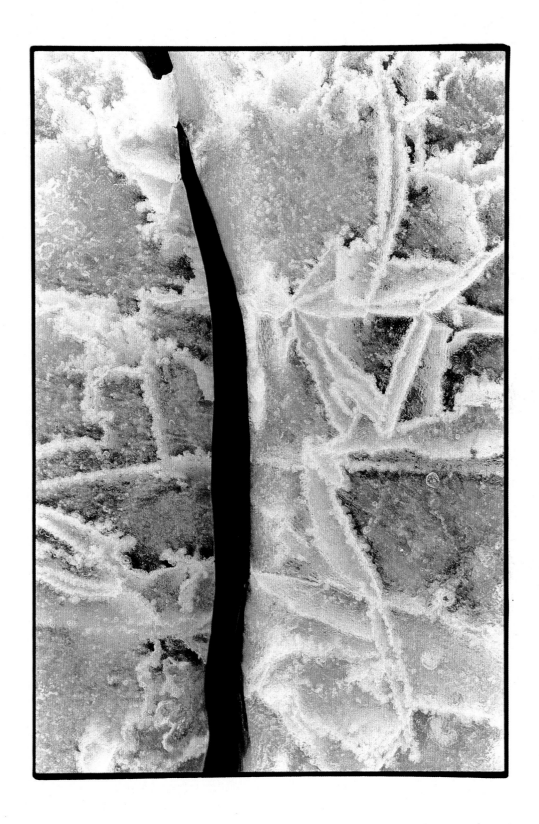

ILLIMANI,
BOLIVIA,
ph. Patrick Wagnon, 1995.

ICE,
ph. Guy Martin Ravel, 1998.

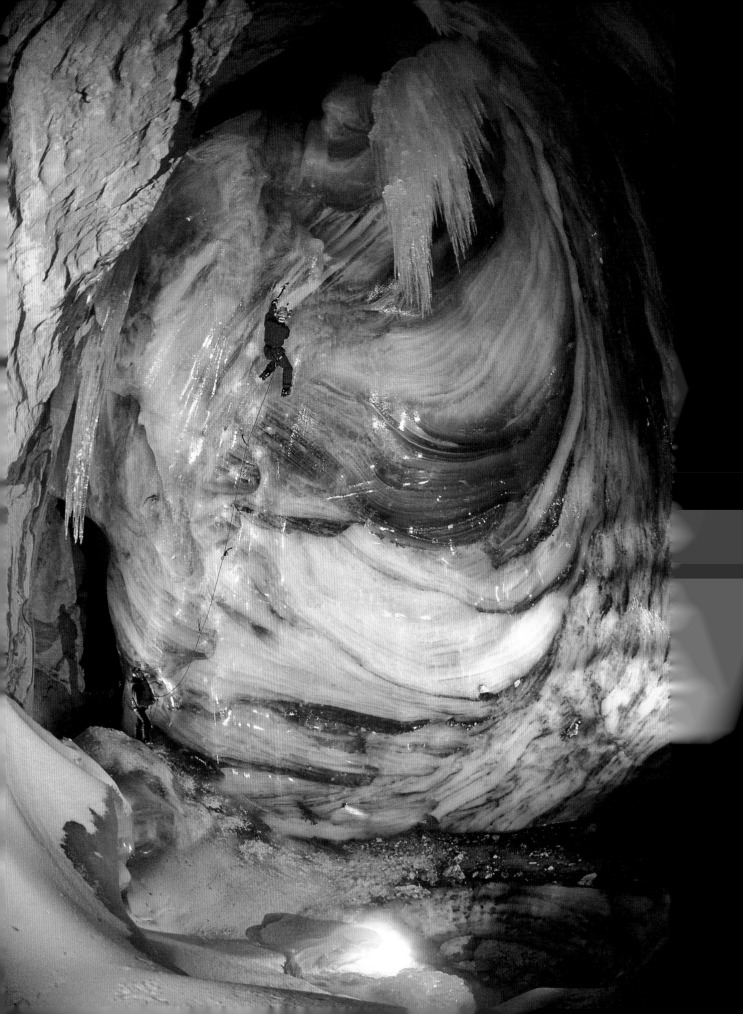

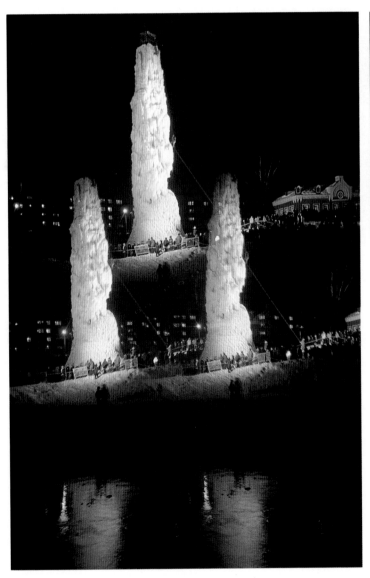

CHOURUM
CLOT DEVOLUY,
FRANCE,
ph. Philippe Poulet, 1997.

ARTIFICIAL ICE,
Kirov, Russia,
ph. Alexei Vokhminzev,
1998.

ARTIFICIAL ICE,
Siberia,
ph. Pavel Sheastemmikov,
1998.

body
corpi
corps
körper
cuerpo

MIRJAM VERBEEK,
Amsterdam,
NETHERLANDS,
ph. Wilfried Zwaans, 1996.

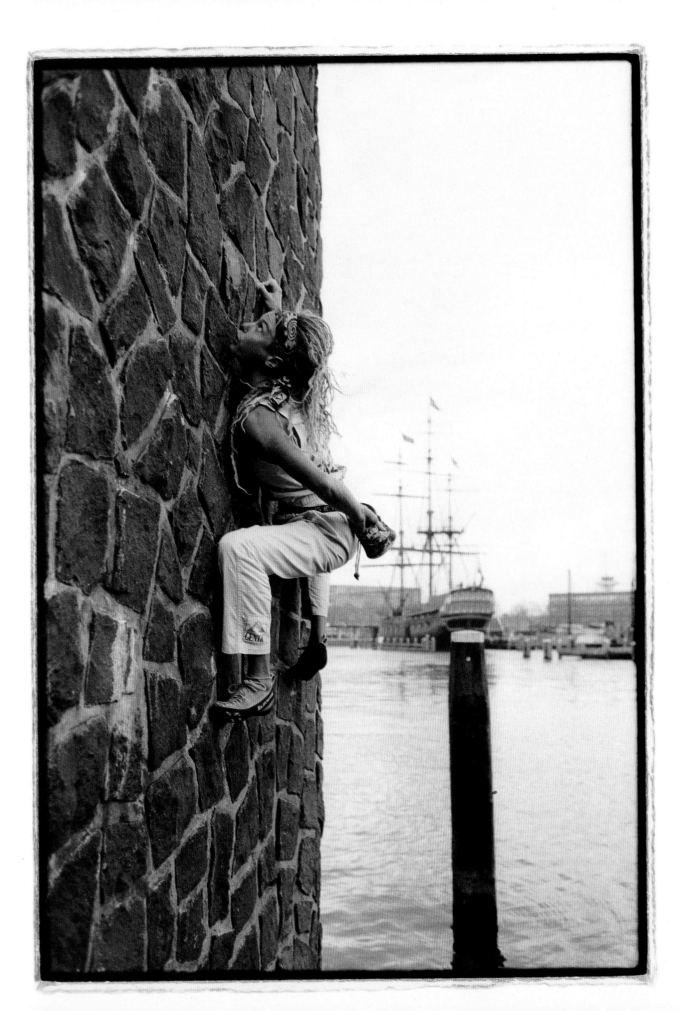

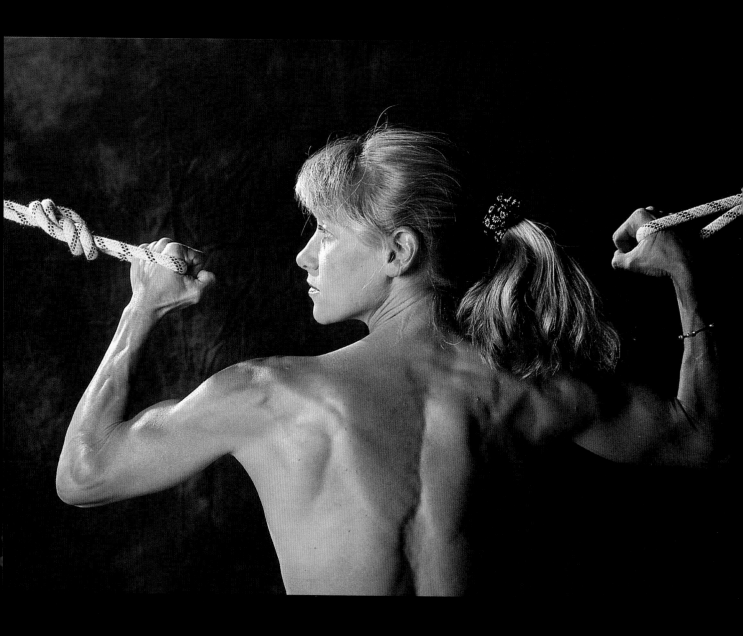

ROBYN
ERBERSFIELD,
ph. Philippe Poulet, 1995.

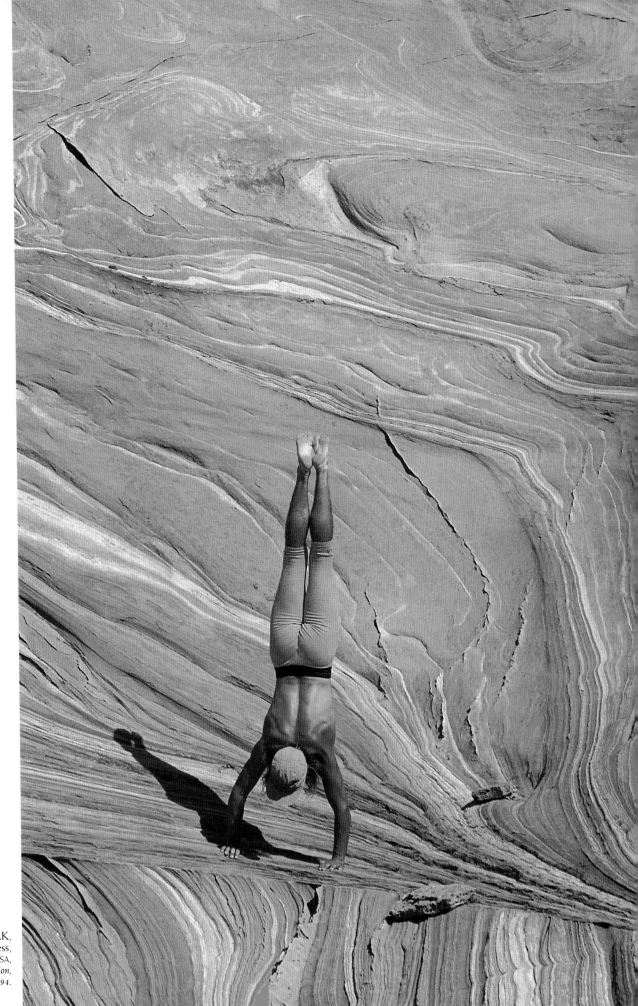

HEINZ ZAK,
Paria Wilderness,
USA,
ph. Heinz Zak collection,
1994.

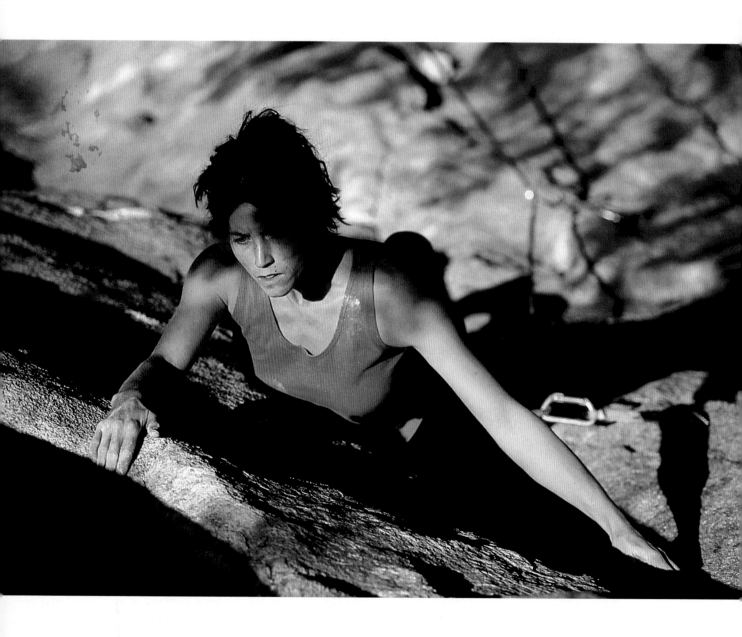

RIKKE ISHOY,
Yosemite,
Usa,
ph. Corey Rich, 1997.

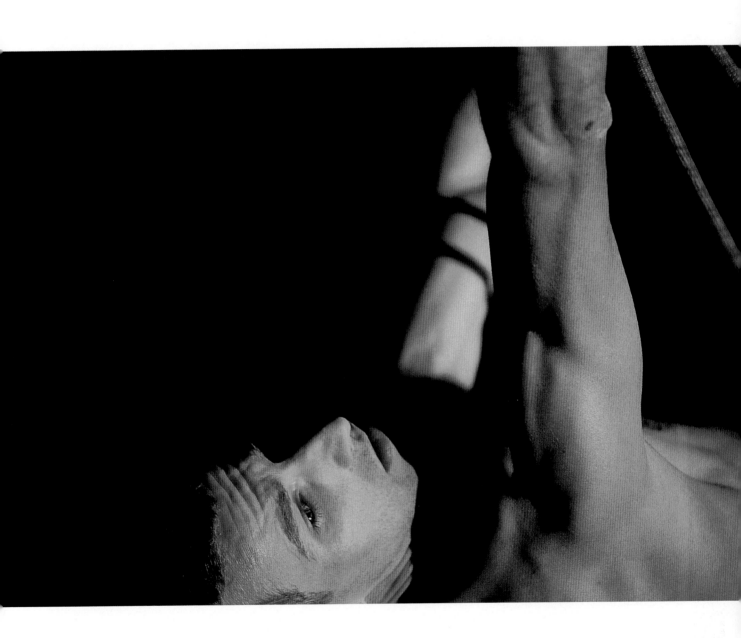

GUIDO CORTESE,
Finale Ligure,
ITALY,
ph. Andrea Gallo, 1998.

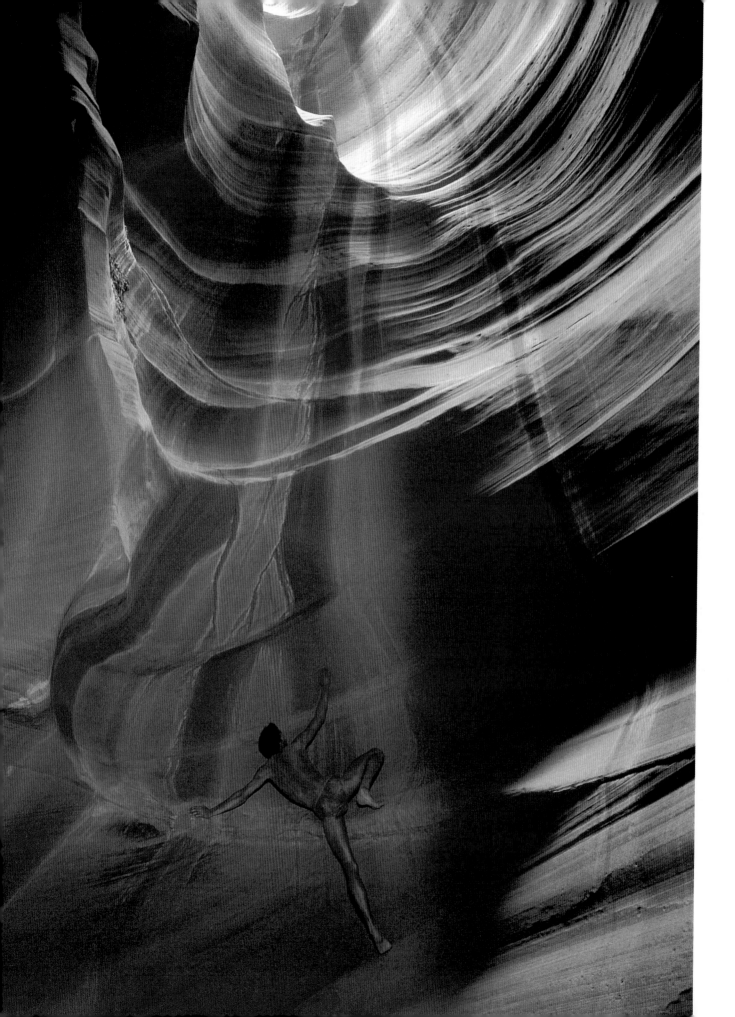

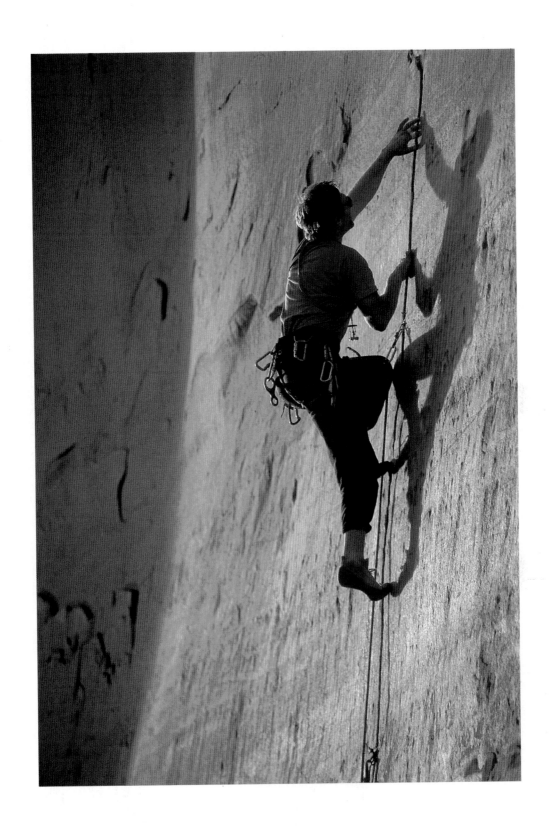

STEFAN KIECHL,
Antelope Canyon,
USA,
ph. Heinz Zak, 1988.

STEVIE HAIRE,
Indian Creek Canyon,
USA,
ph. Kennan Harvey, 1996.

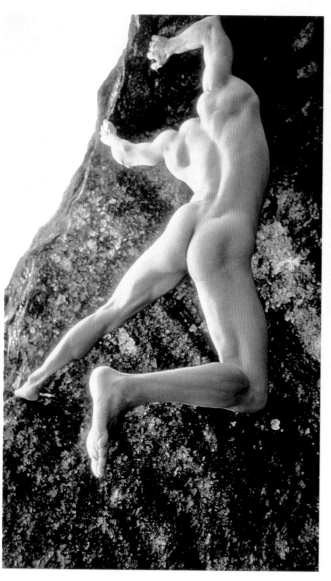

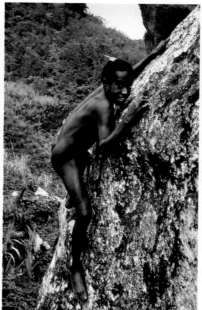

YOUNG DANI,
INDONESIA,
ph. Pat Morrow, 1995.

RENATO DA POZZO,
Masino Valley,
ITALY,
ph. Fulvio Maiani, 1998.

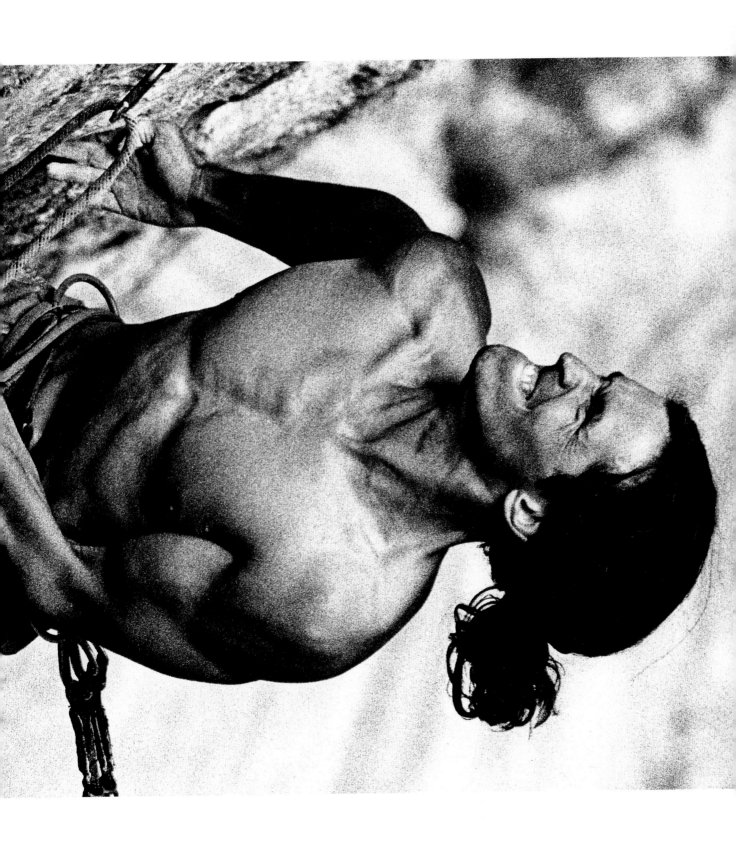

STEFAN
GLOWACZ,
Verdon, FRANCE,
ph. Gerhard Heidorn, 1996.

rock climbing
sulla roccia
grimper le rocher
klettern
escalada en roca

ROCK CLIMBING

STEFAN GLOWACZ,
"Satan's temple",
Waterfall Bowen,
SOUTH AFRICA,
ph. Gerhard Heidorn, 1995.

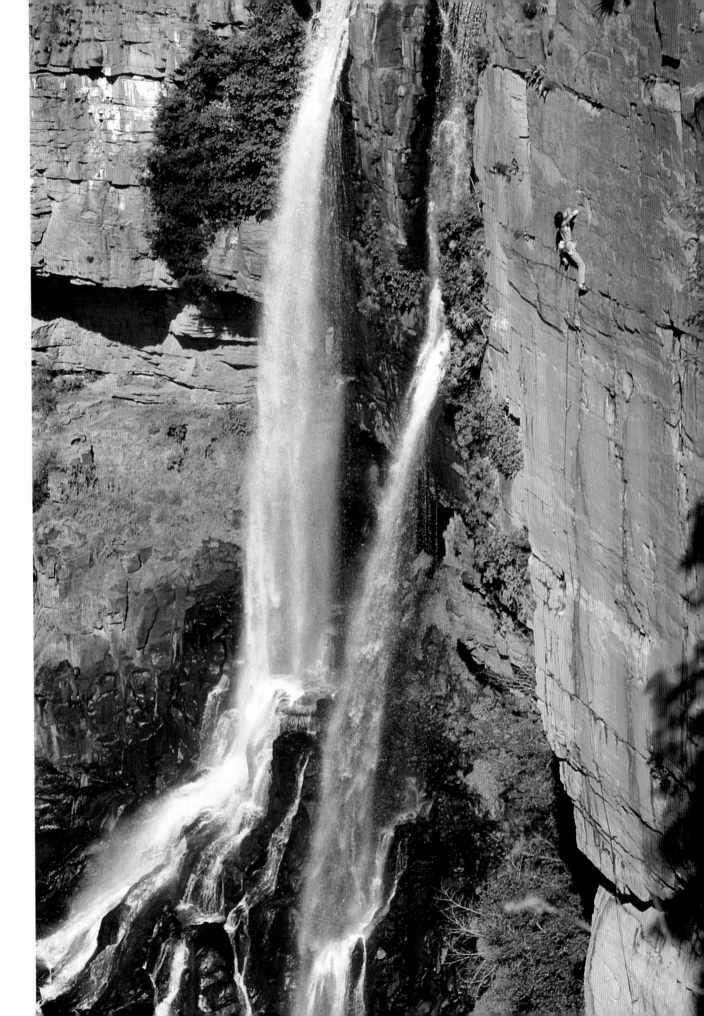

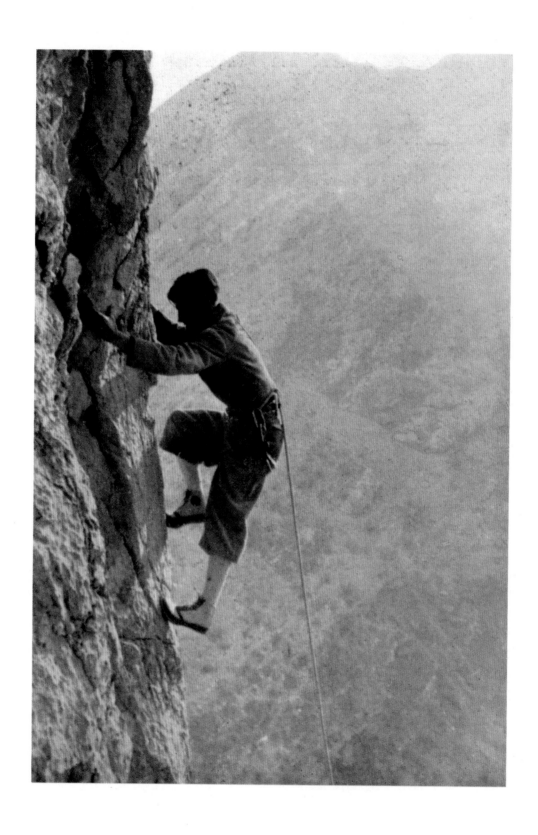

EMILIO COMICI,
Dolomites,
ITALY, 1934.

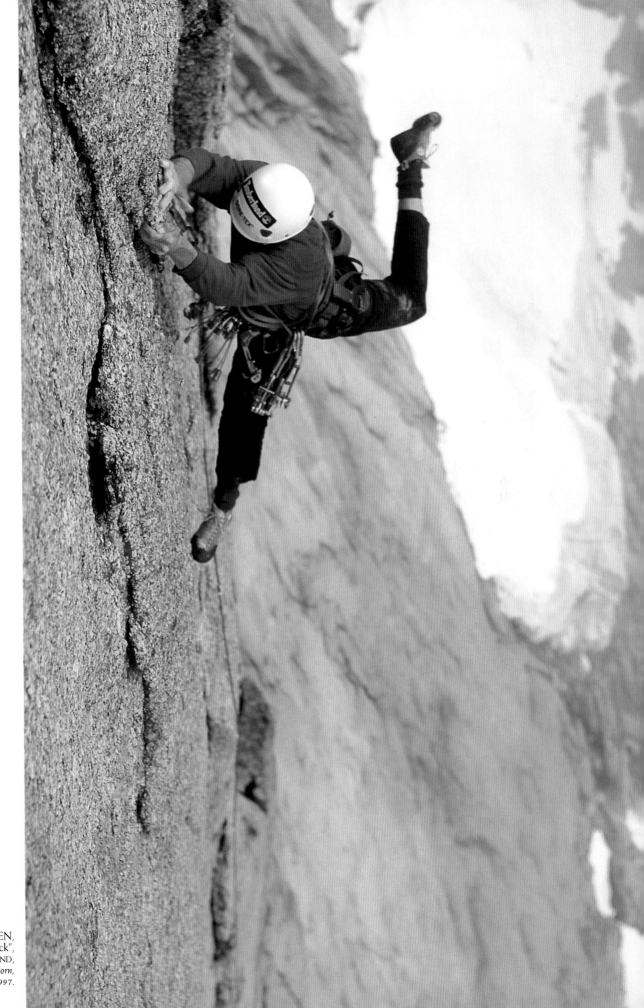

DIDI LANGEN,
"Moby Dick",
GREENLAND,
ph. Gerhard Heidorn,
1997.

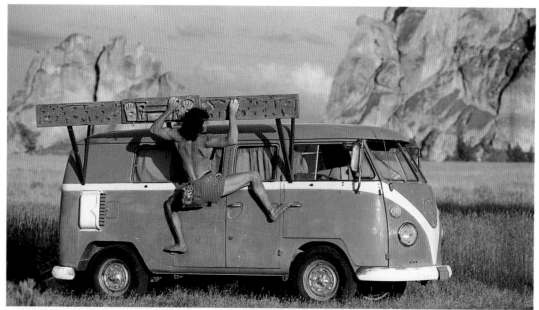

STEFAN
GLOWACZ,
Smith Rock,
USA,
ph. Uli Wiesmeier,
1993.

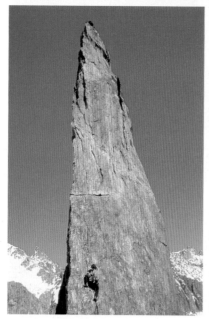

PATRICK BERHAULT,
Père Eternel,
Mont Blanc, ITALY,
ph. Laurent Bouvet, 1997.

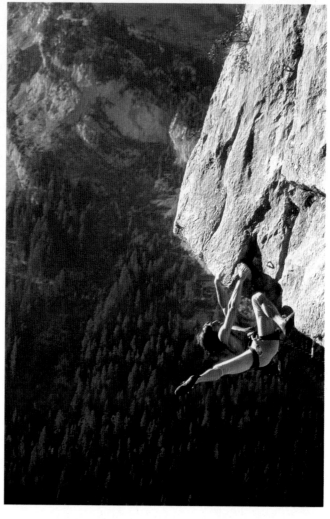

PATRICK BERHAULT,
"Toit d'Augier",
Haute Savoie,
FRANCE,
ph. Laurent Bouvet, 1997.

ZOE BUNDROS,
"Tribal conflict",
Seneca Falls,
USA,
ph. Jim Thornburg,
1995.

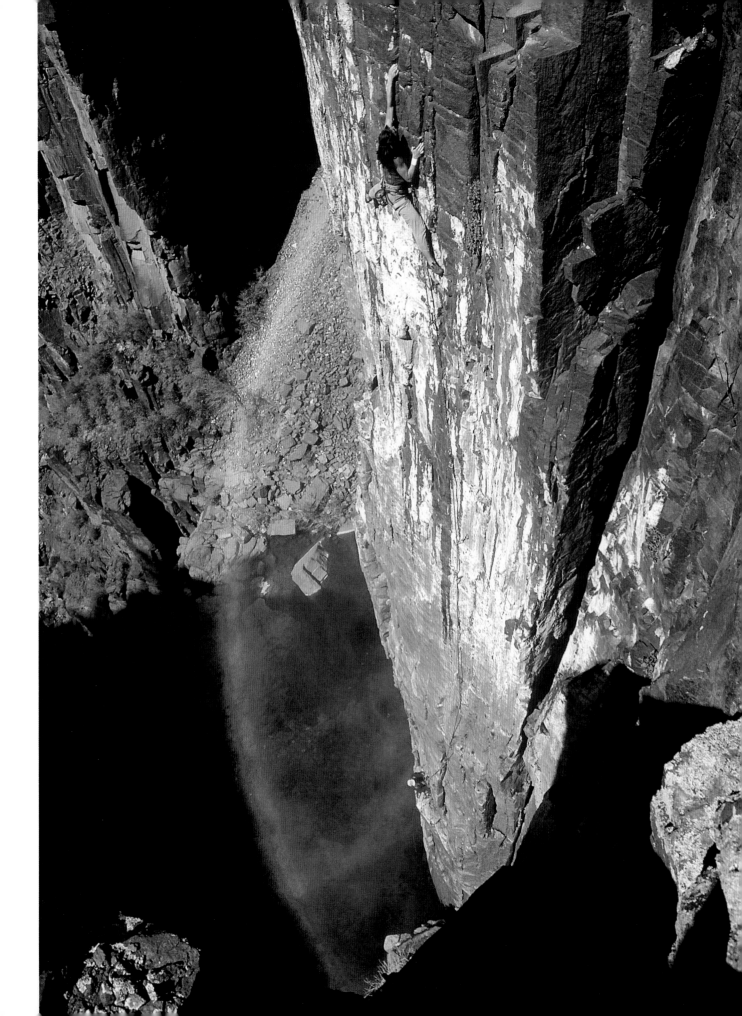

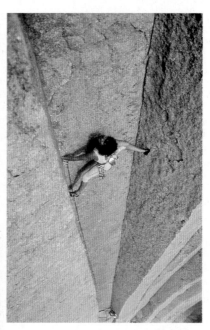

CATHERINE
DESTIVELLE,
"El Matador",
Devil's Tower,
USA,
ph. Beth Wald, 1992.

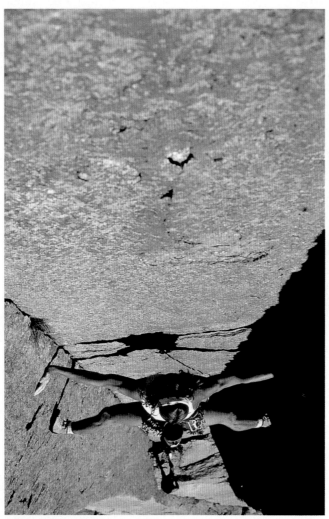

PATRICK EDLINGER,
"El Matador",
Devil's Tower,
USA,
*ph. Gérard Kosicki,
1985.*

ROB HUTCHINSON,
Zion,
USA,
ph. Jim Thornburg, 1996.

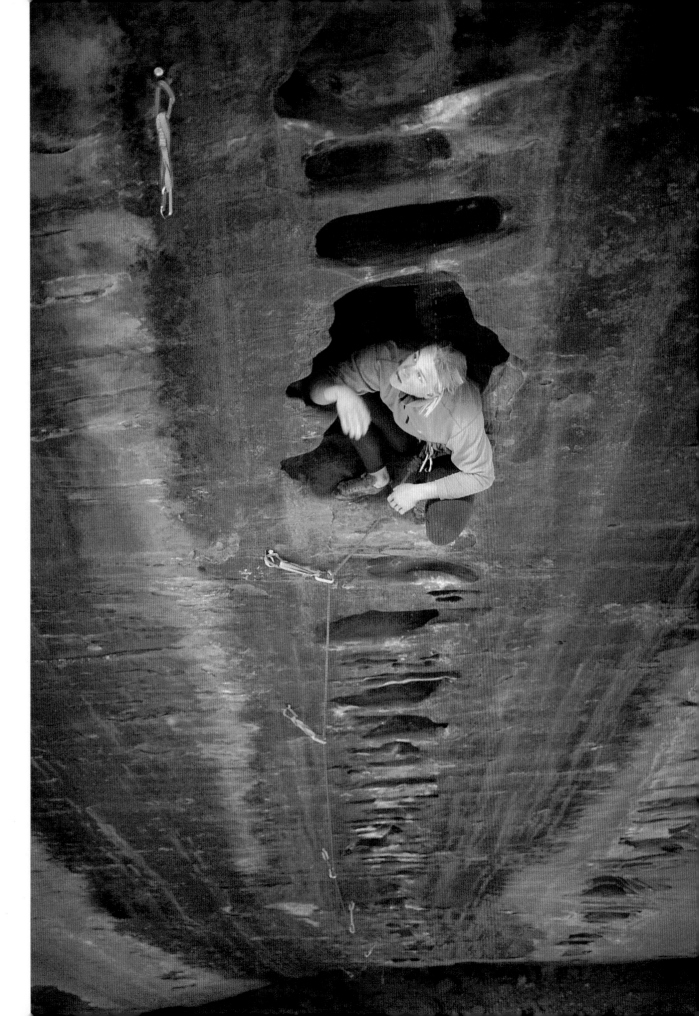

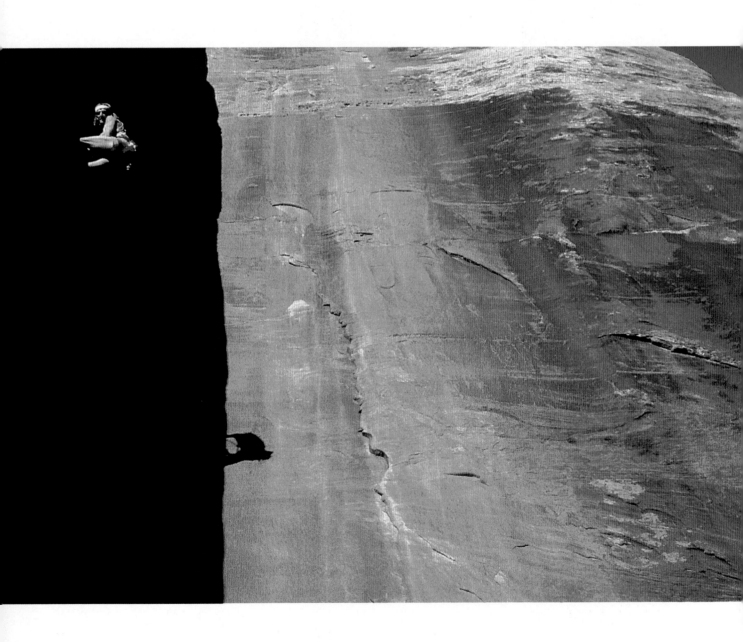

PATRICK EDLINGER,
Indian Creek Canyon,
USA,
ph. Gérard Kosicki, 1985.

TOM GILJE,
"South of Heven",
Joshua Tree,
USA,
ph. Greg Epperson, 1993.

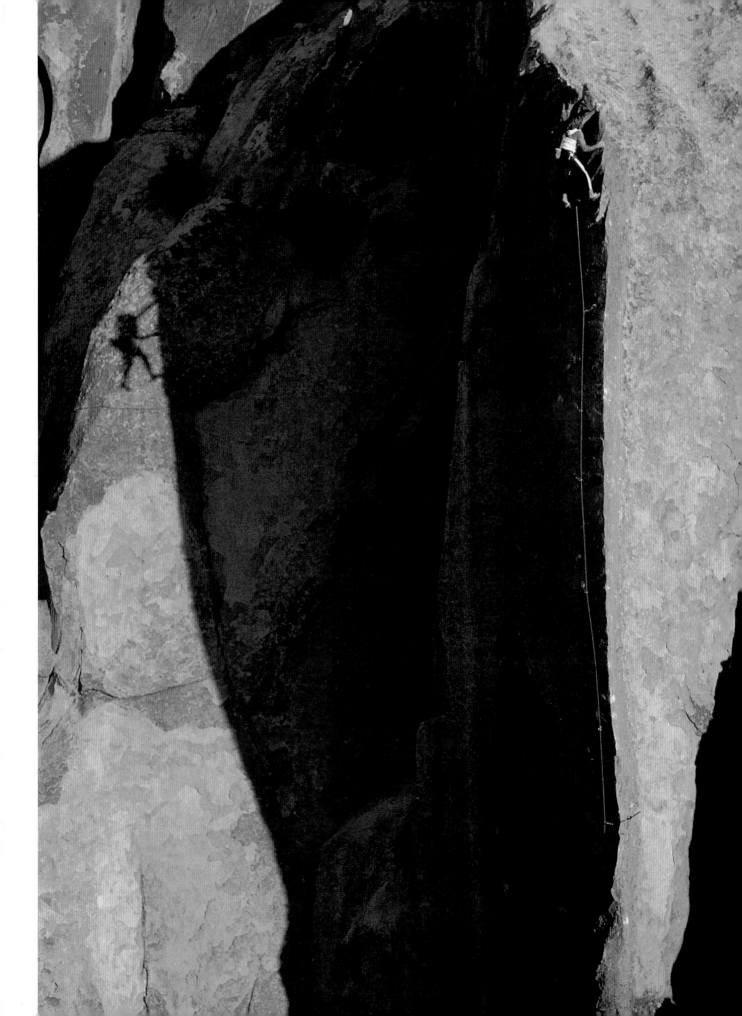

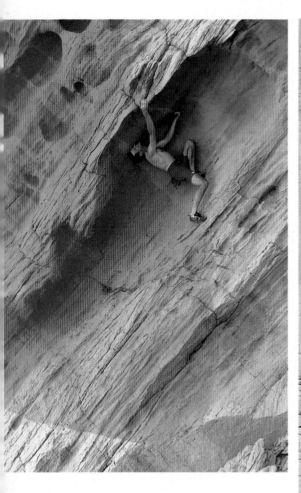

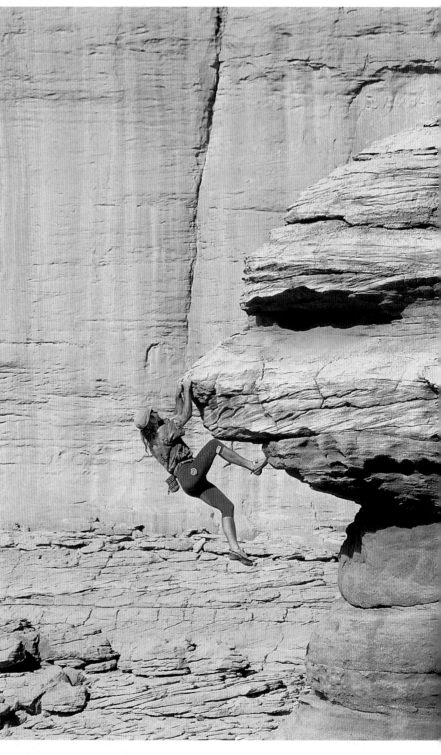

JERRY MOFFAT,
Tibesti,
CIAD,
ph. Heinz Zak, 1994.

HEINZ ZAK,
Tibesti,
CIAD,
ph. Heinz Zak collection, 1994.

KURT ALBERT,
Lotus Mountain,
CHINA,
ph. Heinz Zak, 1987.

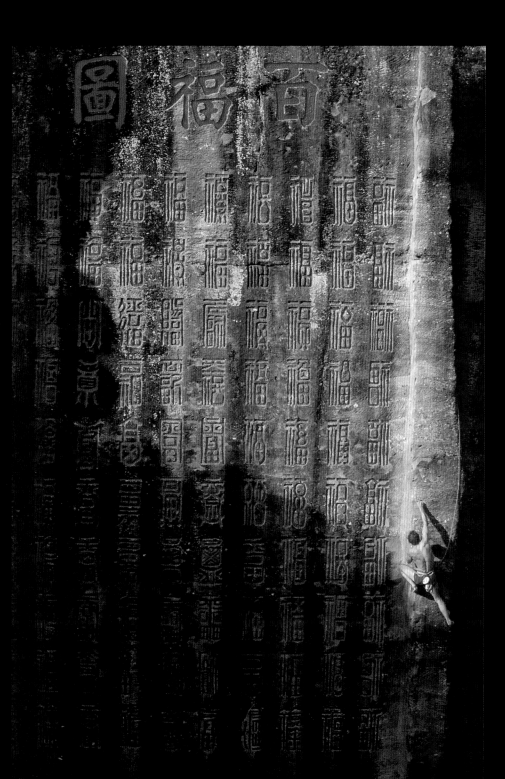

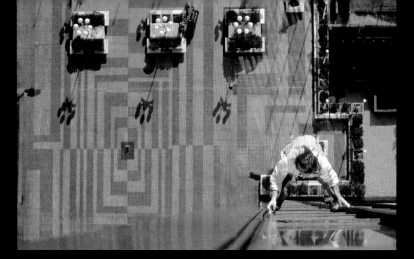
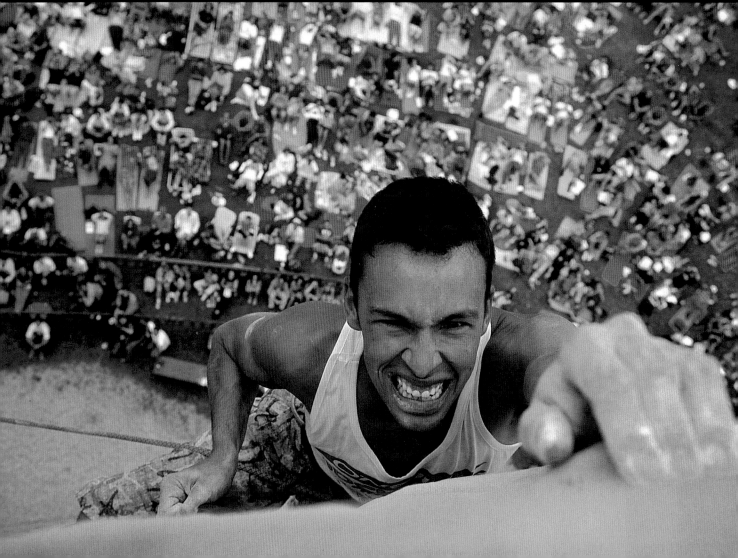

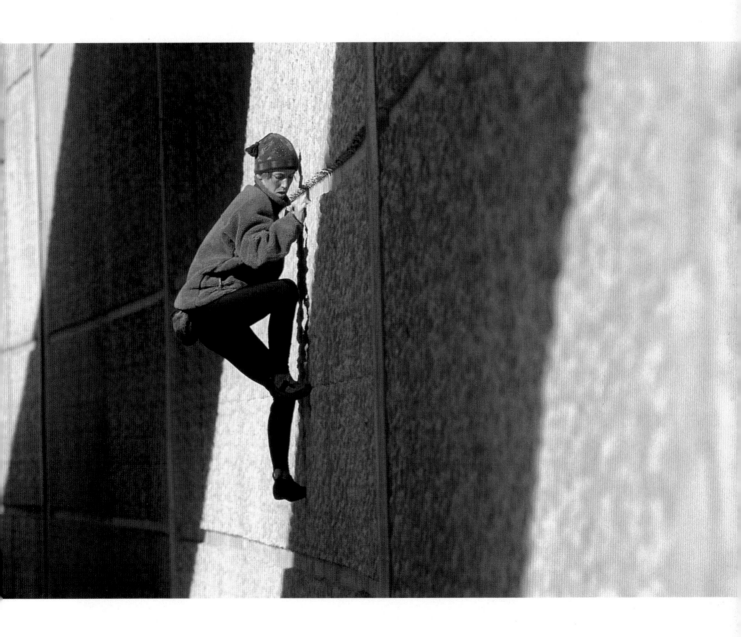

RIKKE ISHOY,
Tucson,
ARIZONA,
ph. Corey Rich, 1998.

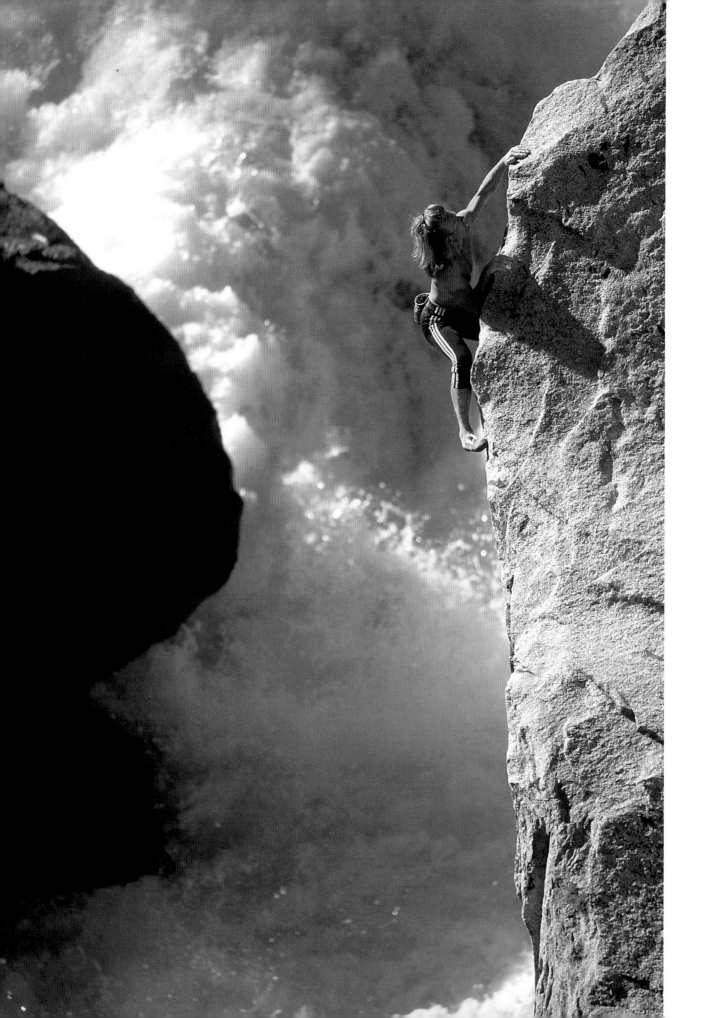

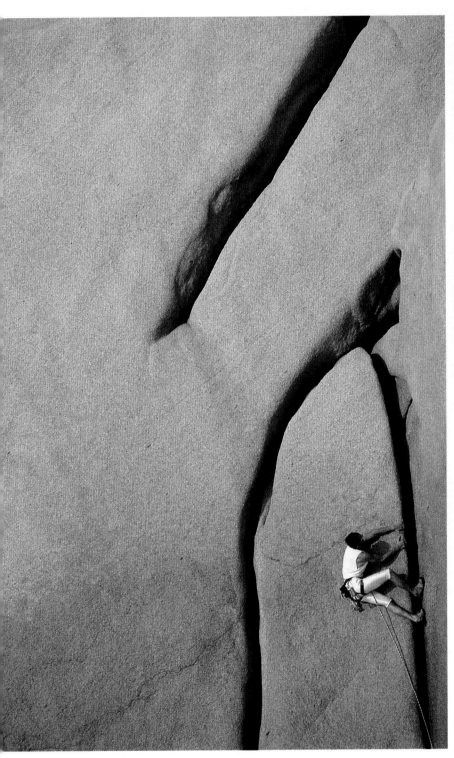

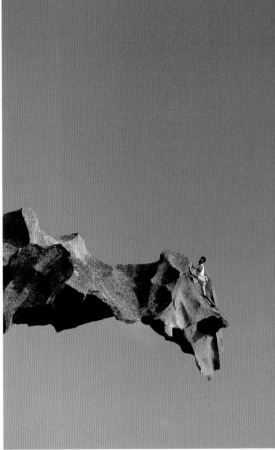

JEAN MICHEL CASANOVA,
Sardinia,
ITALY,
ph. Philippe Poulet, 1992.

BEAT KAMMERLANDER,
Merced River,
Yosemite, USA,
ph. Peter Mathis, 1998.

JEAN MICHEL
CASANOVA,
Sardinia,
ITALY,
ph. Philippe Poulet, 1992.

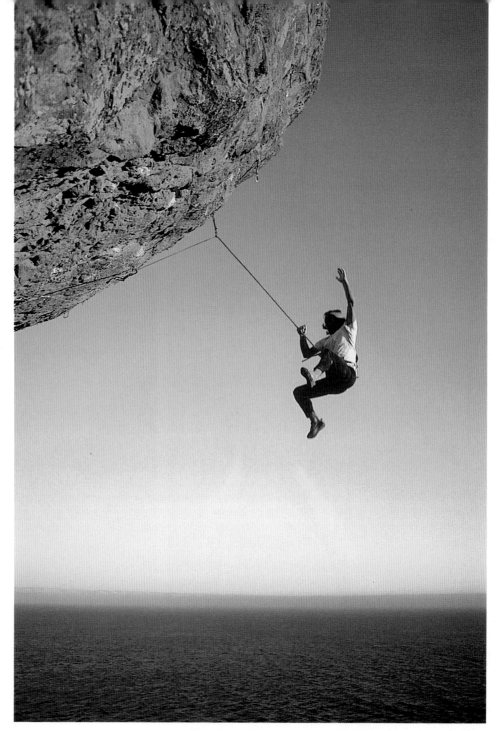

RON KAUK,
"Surf safary",
Mickey's Beach,
USA,
ph. Jim Thornburg, 1996.

KEVIN GALLAGER,
"Los remotos",
El Potrero Chico,
MEXICO,
ph. Corey Rich, 1996.

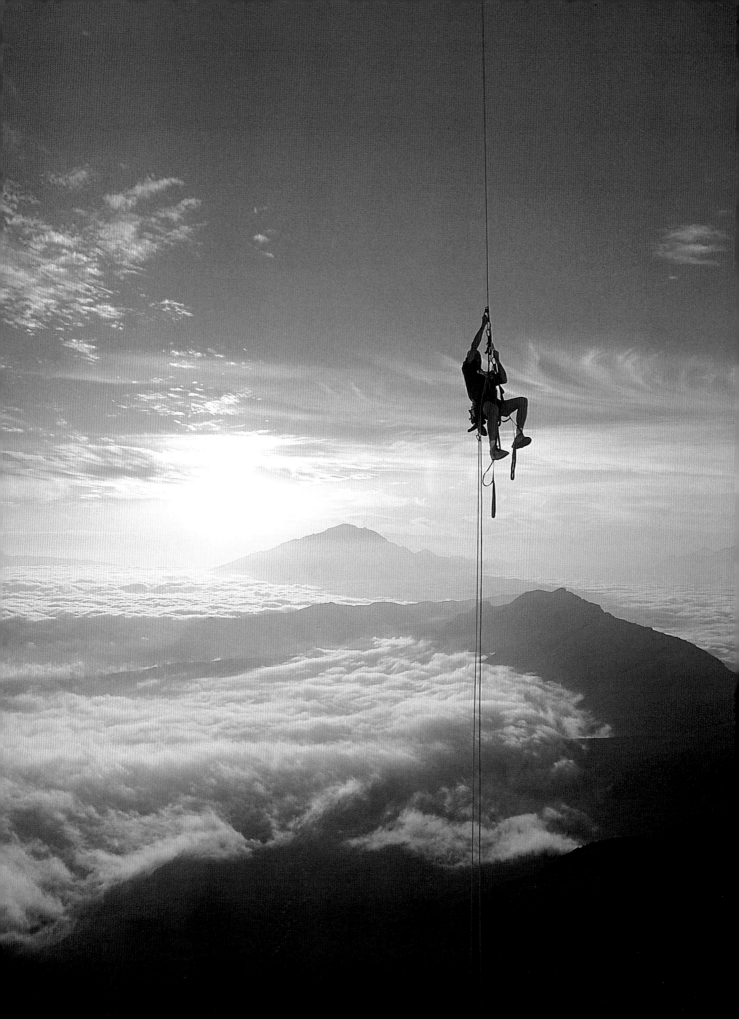

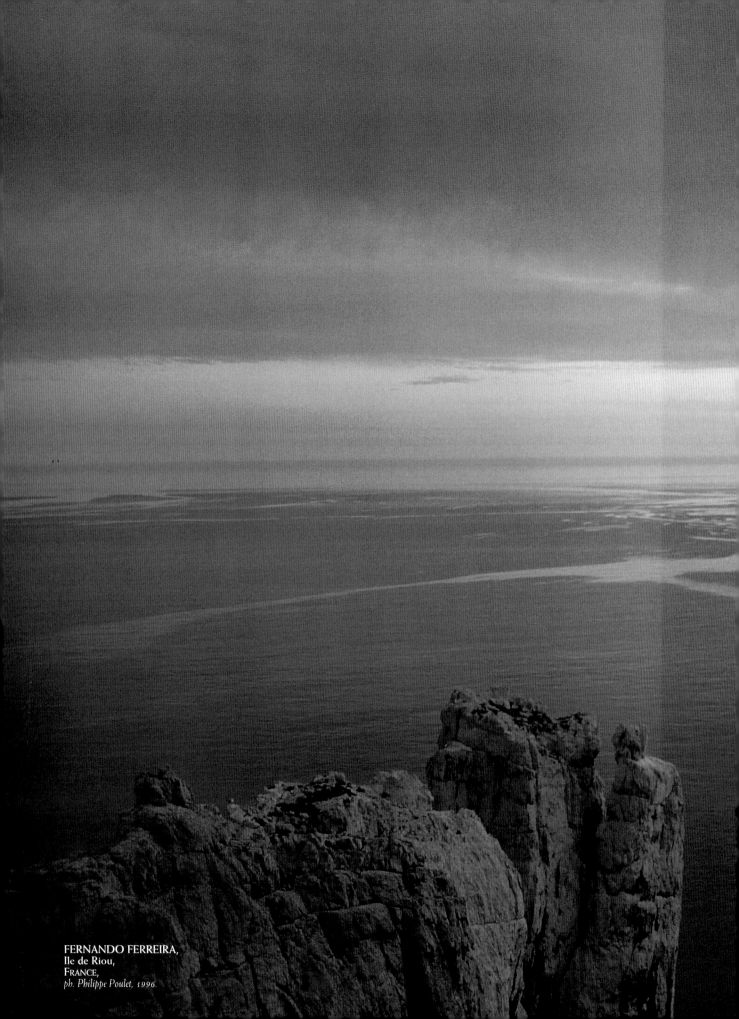

FERNANDO FERREIRA,
Ile de Riou,
FRANCE,
ph. Philippe Poulet, 1996.

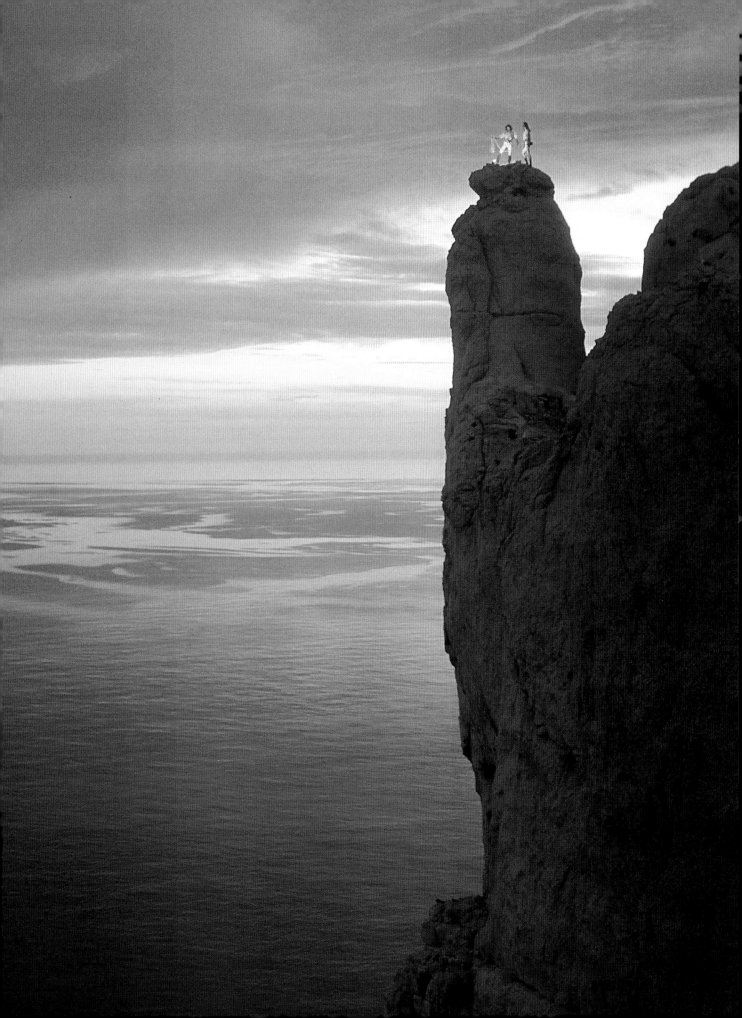

ice climbing
sul ghiaccio
grimper la glace
eisklettern
escalada en hielo

ICE
CLIMB
ING

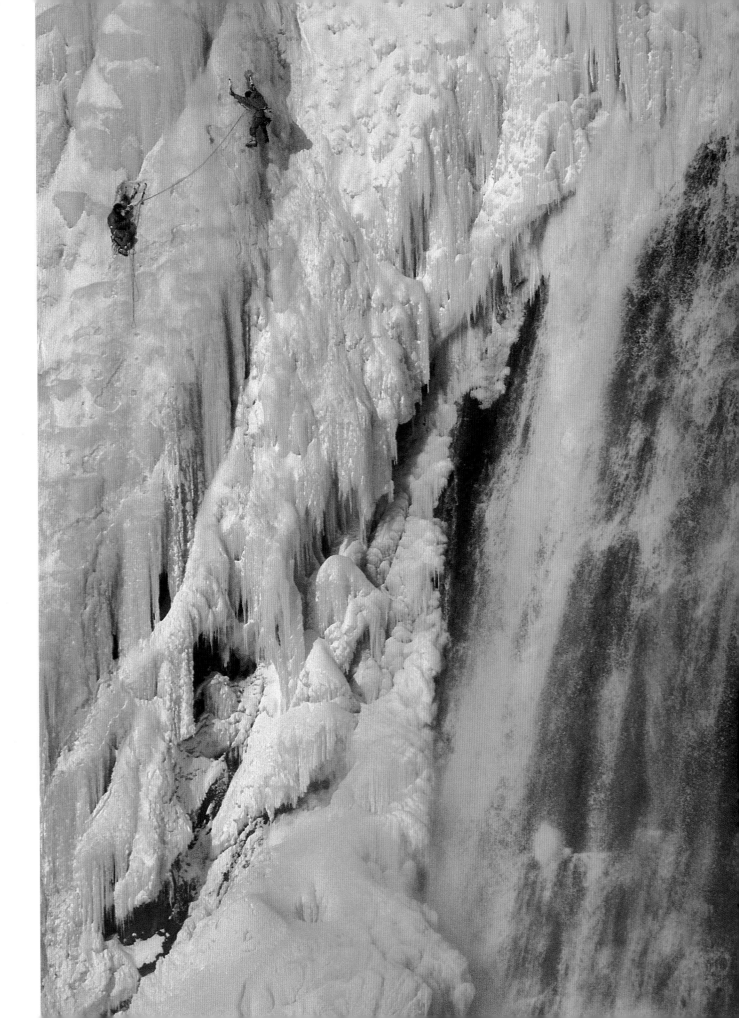

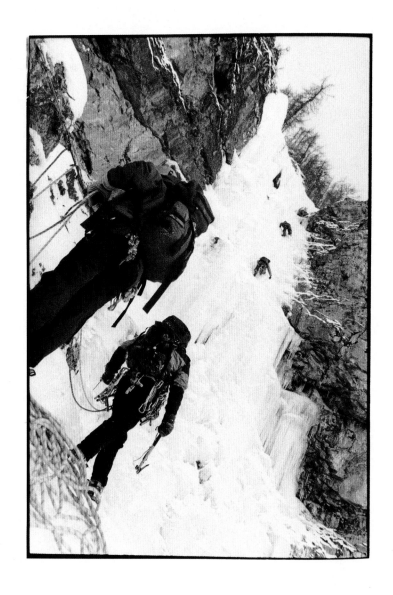

LA GRAVE,
Oisans,
FRANCE,
ph. Benjamin Mazuer, 1998.

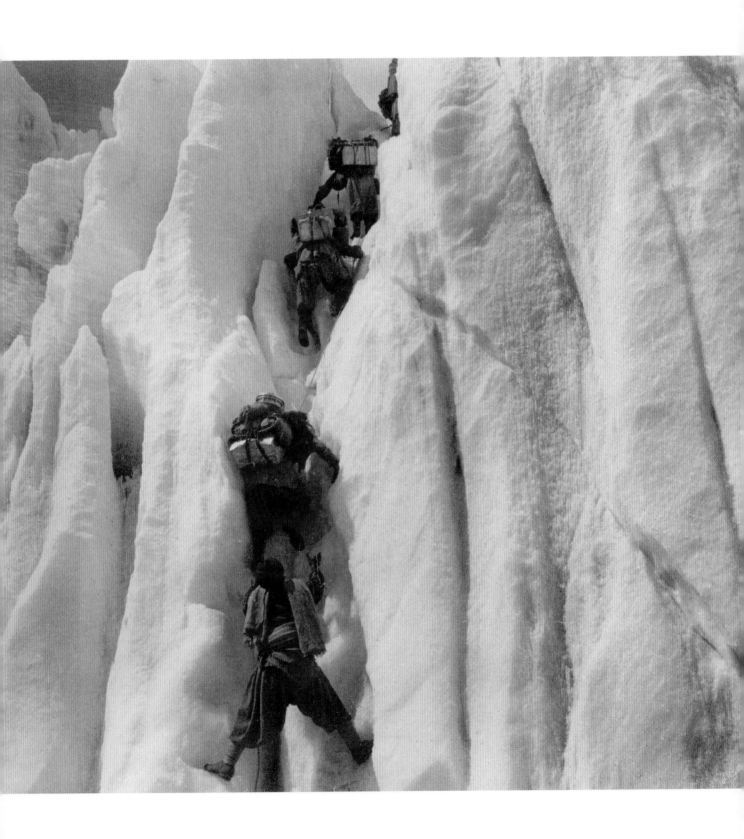

GASHERBRUM GLACIER,
PAKISTAN,
*ph. Umberto Balestrieri/Archivio Museo
della Montagna di Torino, 1929.*

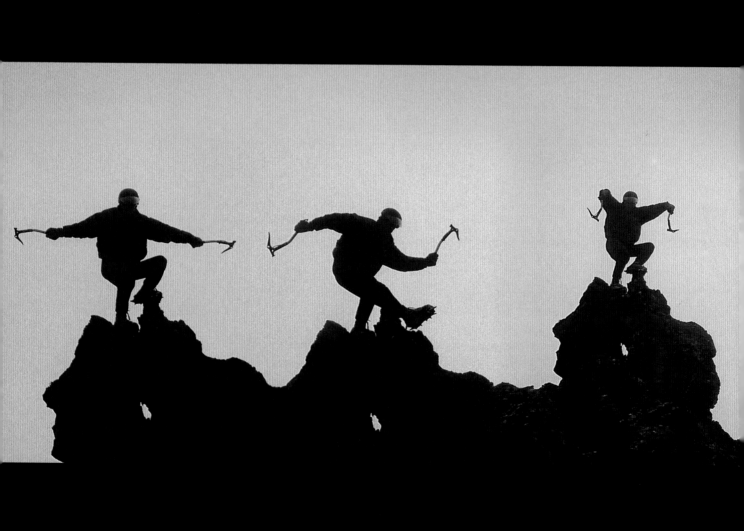

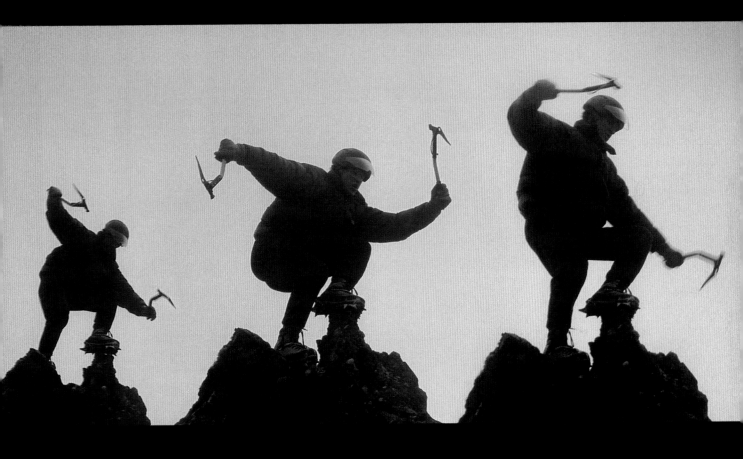

CHRISTOPHE
MOULIN,
ICELAND,
ph. Nicholas Moulin, 1998.

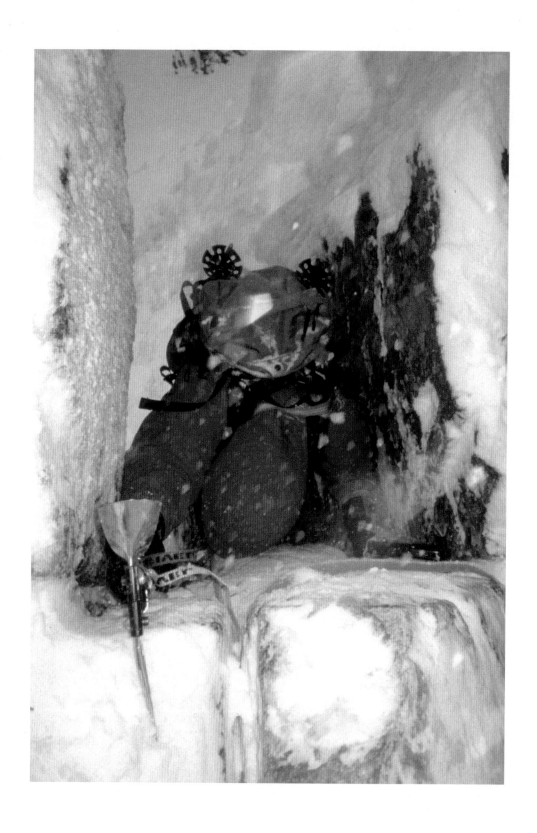

MANU IBARRA,
"Tower Ridge",
Ben Nevis,
SCOTLAND,
ph. Manu Ibarra collection, 1996.

ROBERT JASPER,
"Flying circus",
Oberland,
SWITZERLAND,
ph. Thomas Ulrich, 1996.

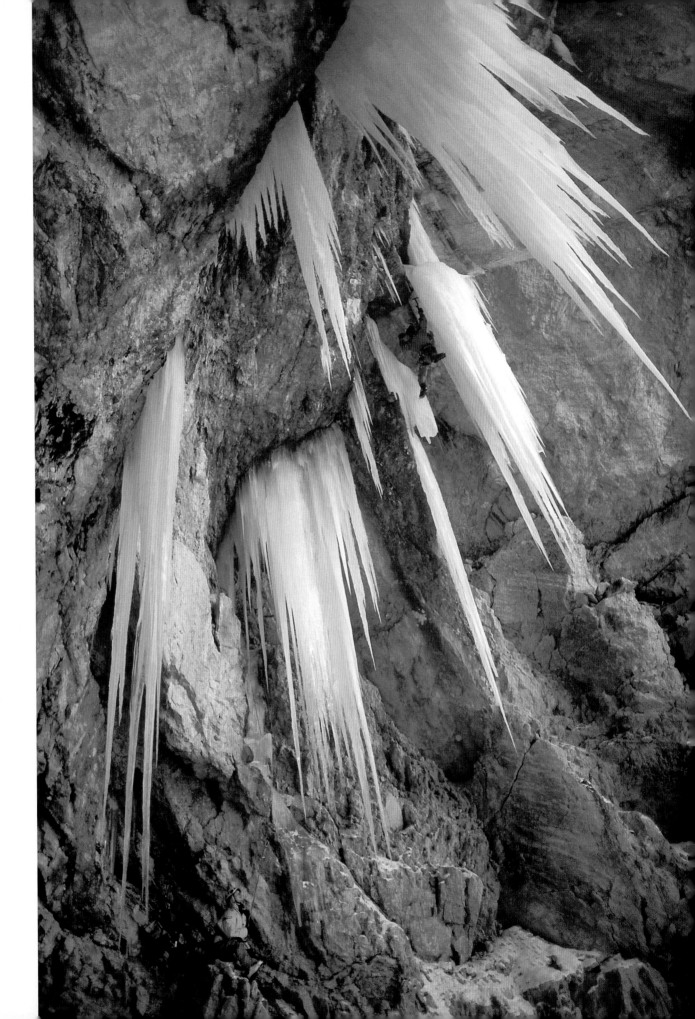

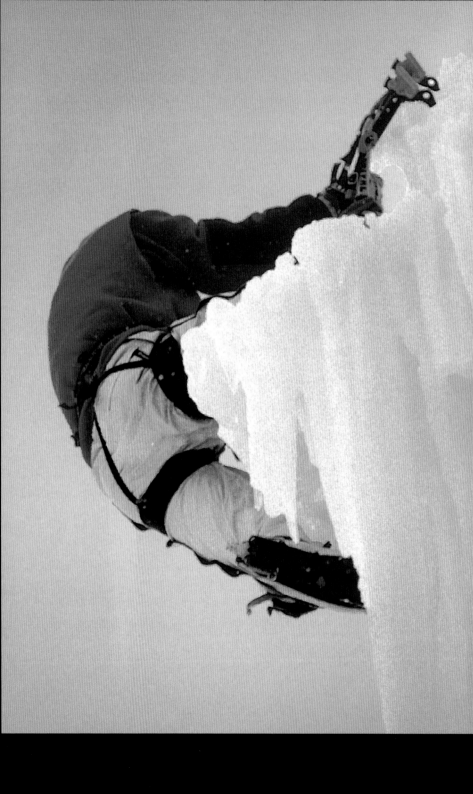

CHRISTOPHE MOULIN,
Formazza Valley,
ITALY,
ph. Oliviero Gobbi, 1997.

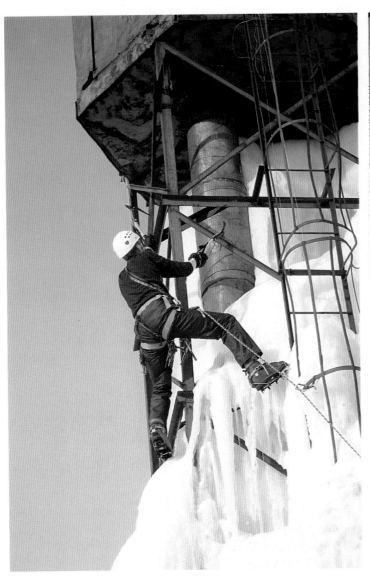

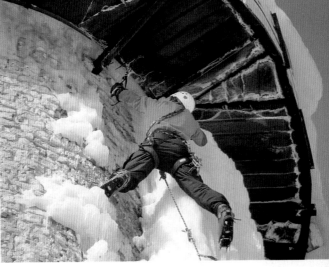

ARTIFICIAL ICE,
RUSSIA,
ph. Pavel Sheastemmikov, 1998.

PAVEL SHABALIN,
SIBERIA,
ph. Alexei Vokhminzev, 1998.

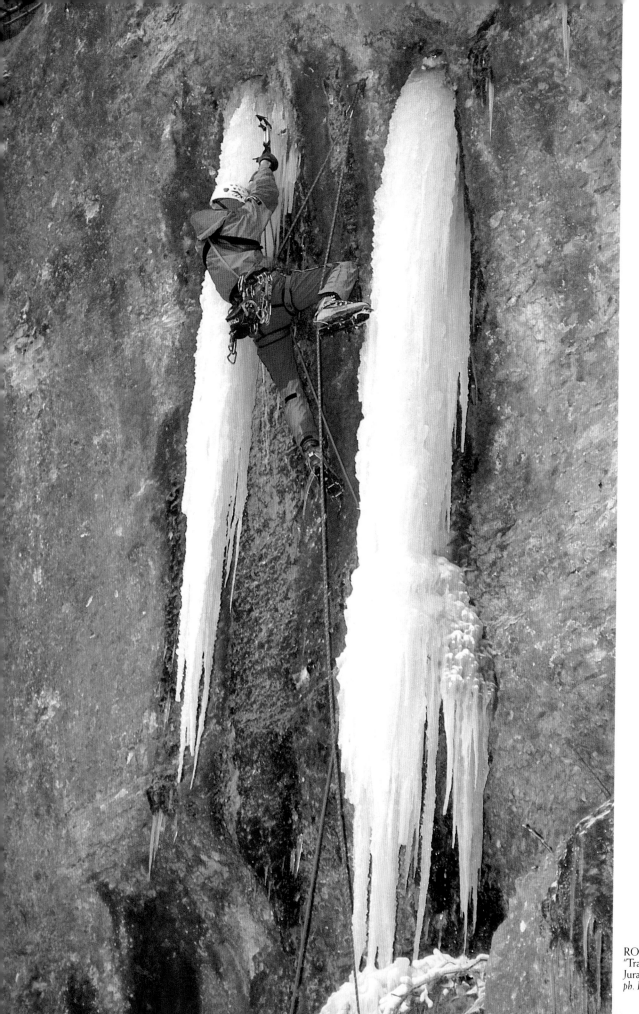

ROBERT JASPER,
"Trait de lune",
Jura, SWITZERLAND,
ph. Robert Bösch, 1997.

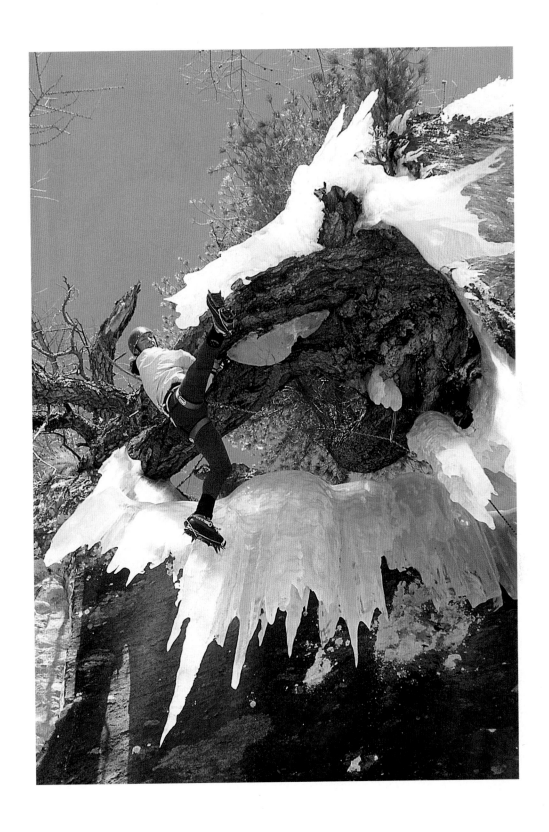

STEVIE HASTON,
"Total madness",
Valsavarenche, ITALY,
ph. Laurence Gouault, 1997.

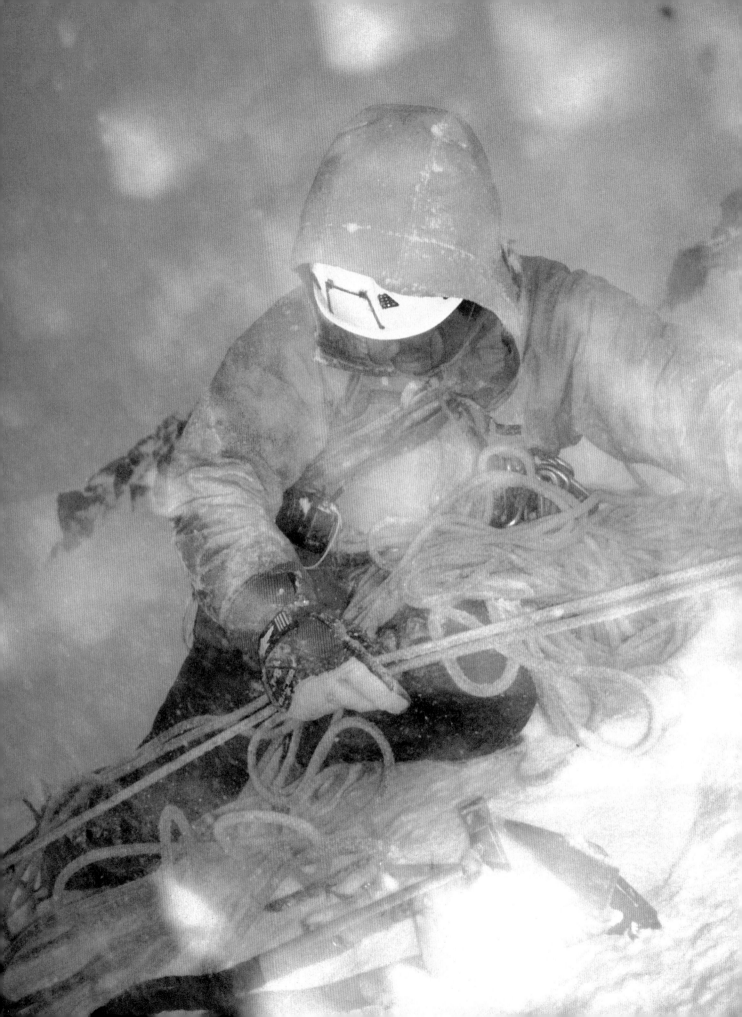

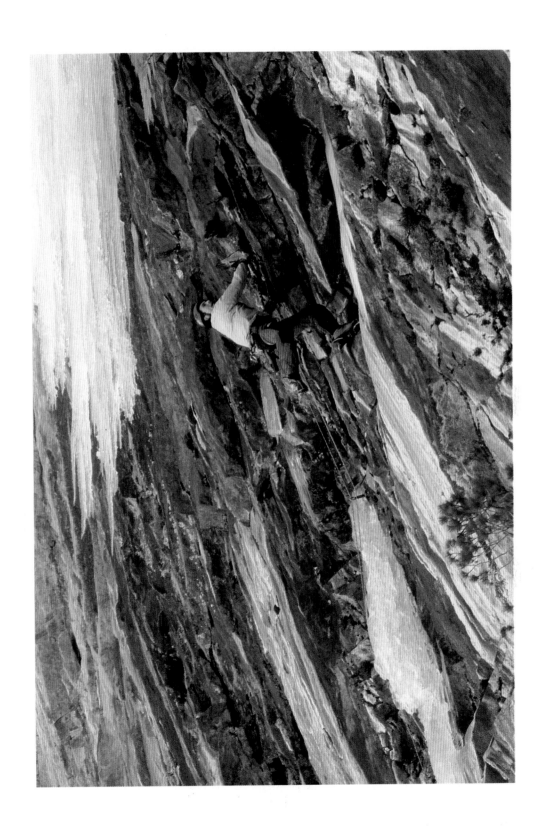

MANU IBARRA,
"Point Five Gully",
Ben Nevis, SCOTLAND,
ph. Manu Ibarra collection, 1993.

STEVIE HASTON,
"X-Files",
Cogne Valley, ITALY,
ph. Laurence Gouault, 1997.

alpinism
alpinismo
alpinisme
alpinismus
alpinismo

STEFAN GLOWACZ,
Cerro Torre, ARGENTINA,
ph. Uli Wiesmeier, 1994.

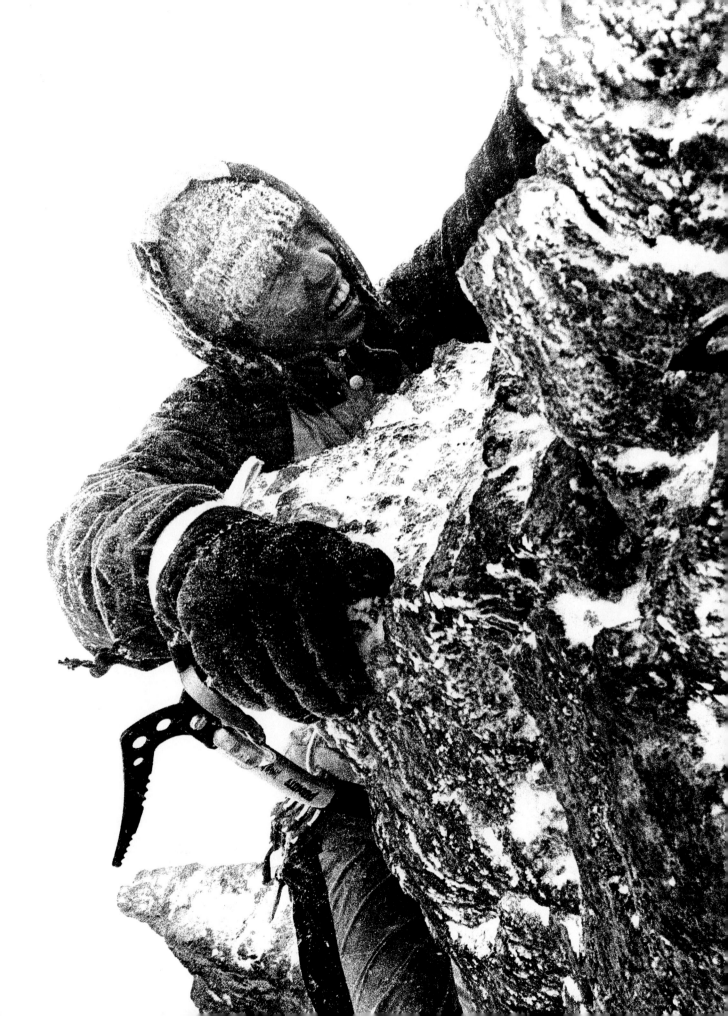

LHOTSE,
NEPAL,
ph. Xavier Murillo, 1987.

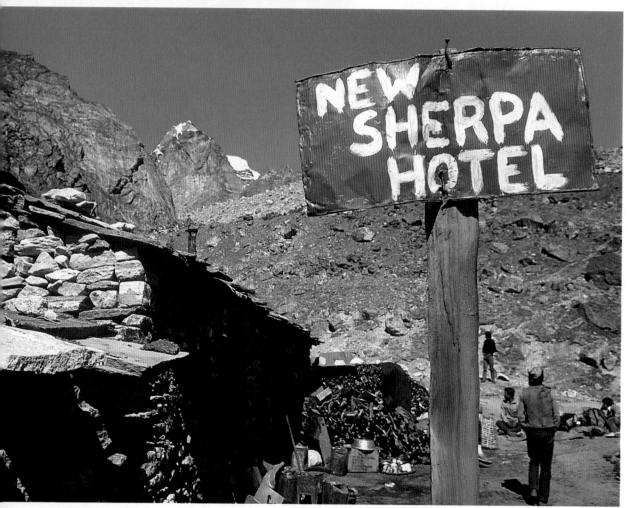

KHUMBU VALLEY,
NEPAL,
ph. Xavier Murillo, 1987.

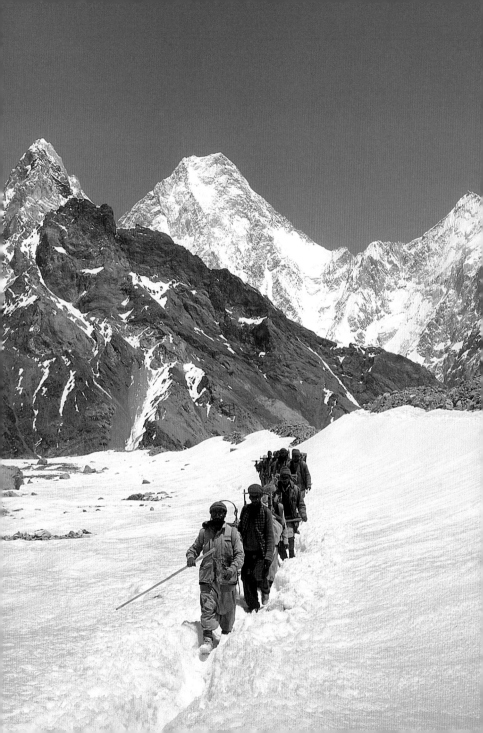

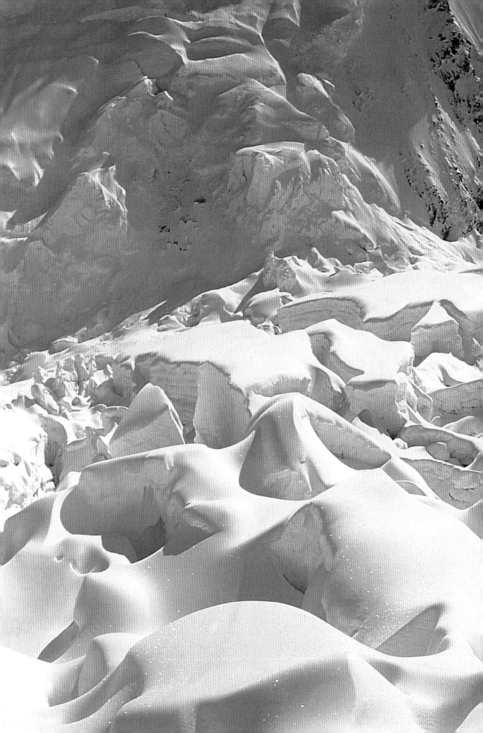

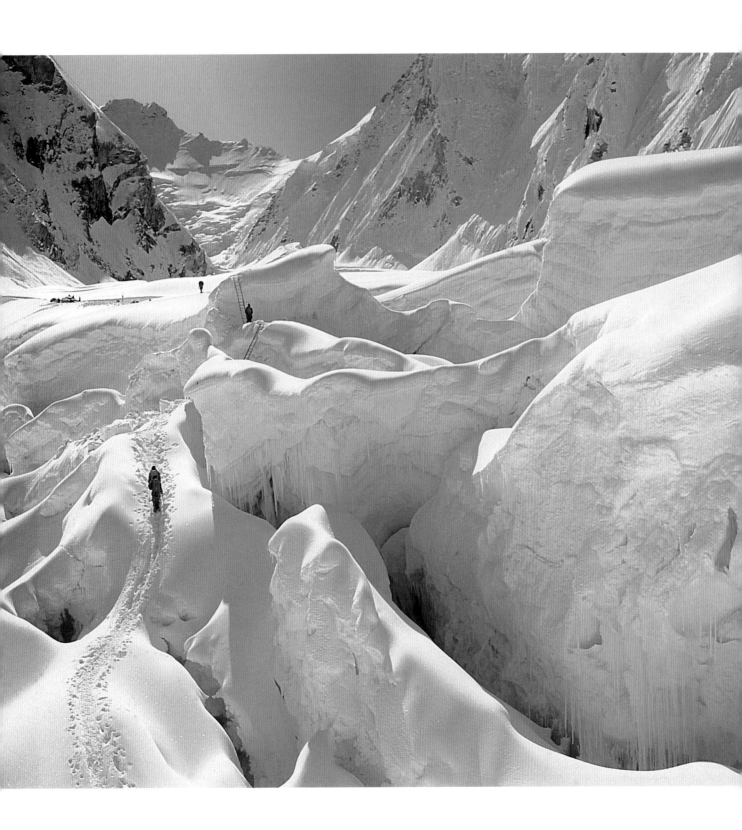

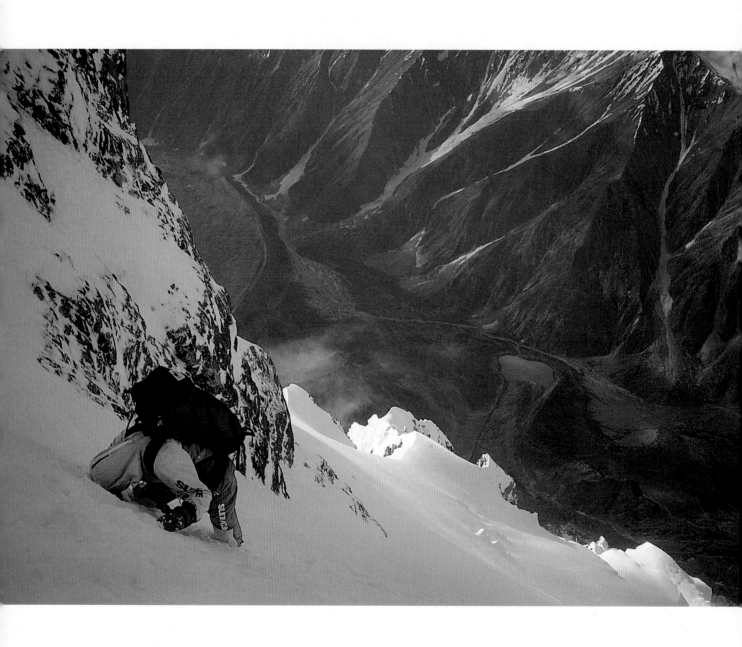

WARD ROBINSON,
Nanga Parbat, PAKISTAN,
ph. Mark F. Twight, 1988.

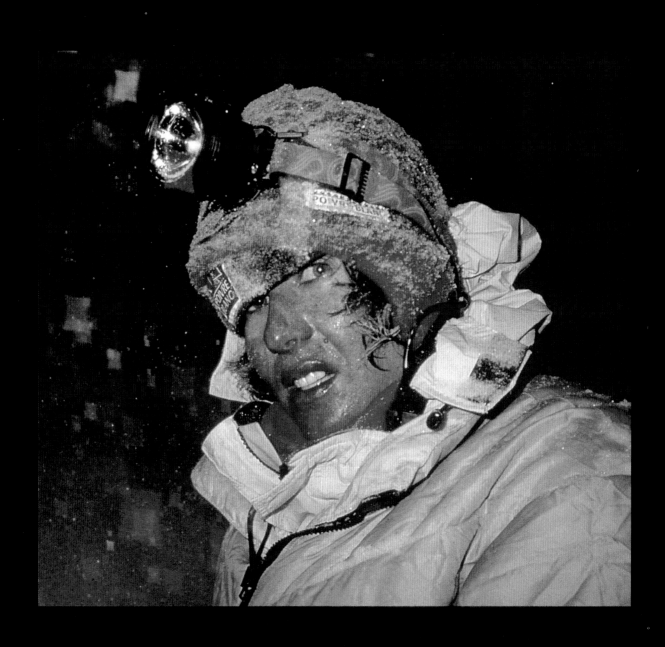

CATHERINE DESTIVELLE,
Shisha Pagma, NEPAL,
ph. Erik Decamp, 1995.

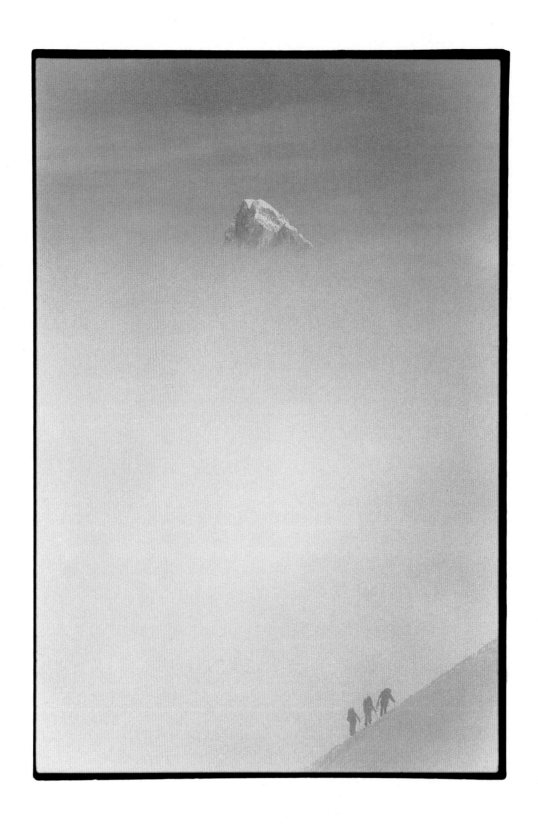

AIGUILLE DU MIDI,
Mont Blanc, FRANCE,
ph. Guy Martin Ravel, 1996.

GASTON REBUFFAT,
Gendarme
du Pic de Roc, FRANCE,
ph. Rébuffat collection, 1955.

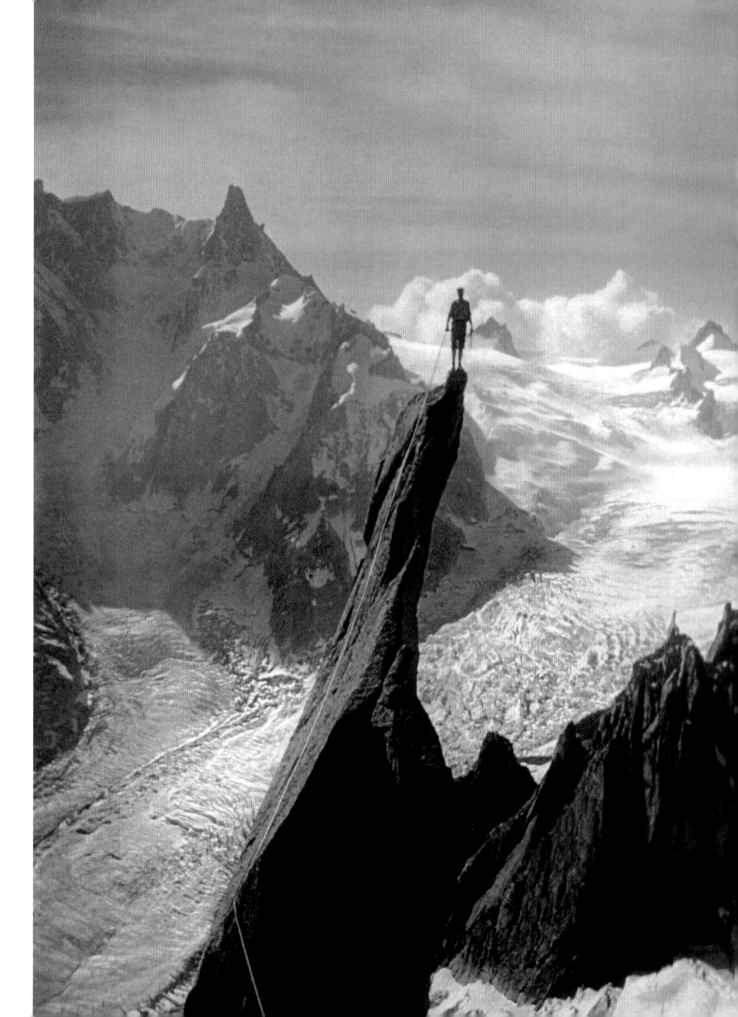

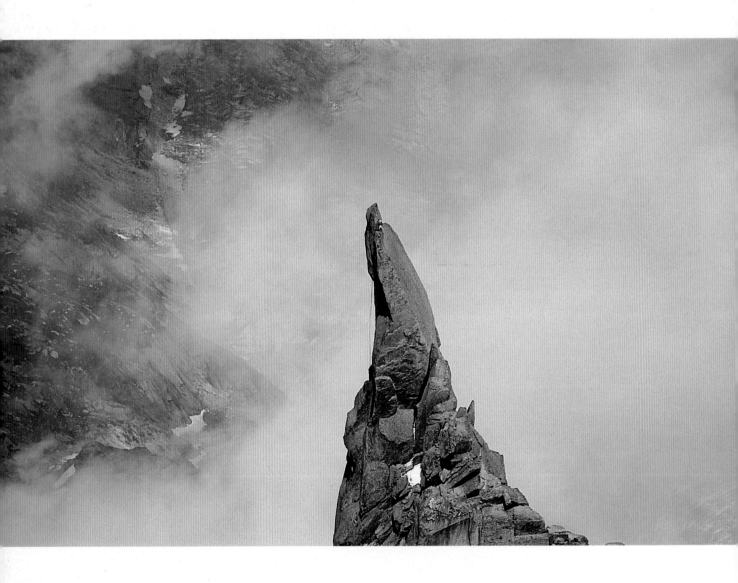

LIONNEL WIBAULT,
Aiguille de la Republique,
Mont Blanc, FRANCE,
ph. Sylvie Chappaz, 1995.

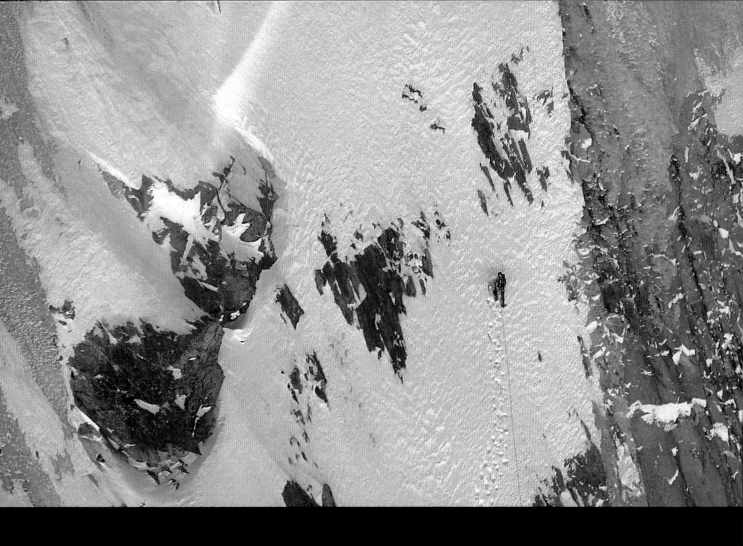

CHRISTOPHE PROFIT,
Grandes Jorasses, Mont Blanc,
FRANCE,
ph. Jean Michel Asselin, 1987.

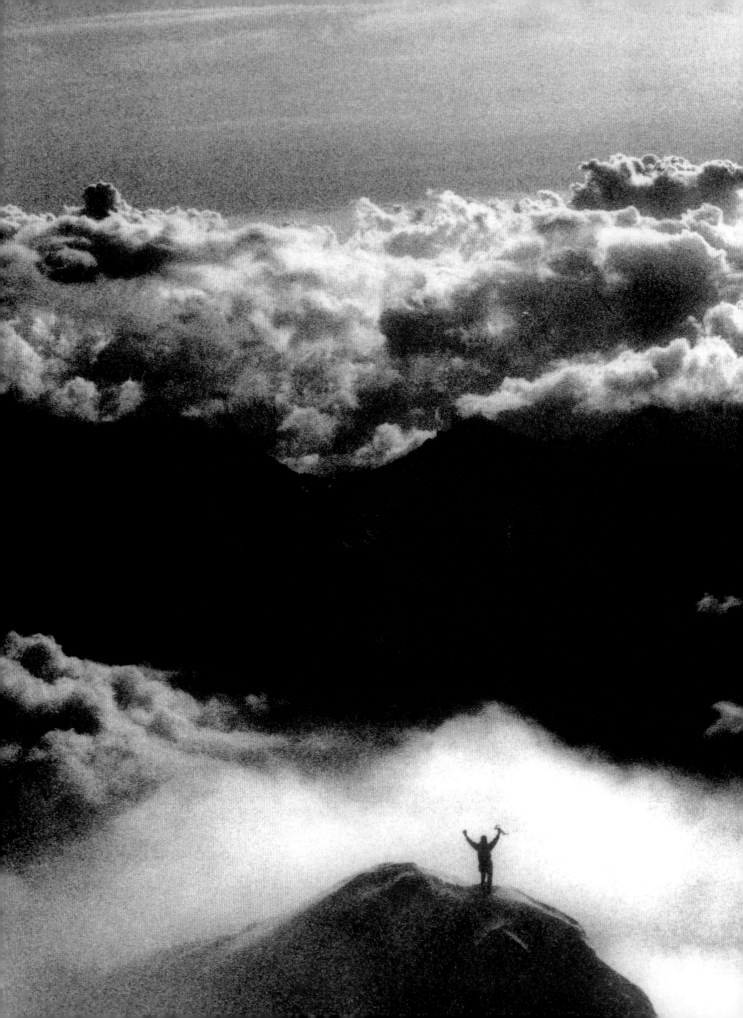

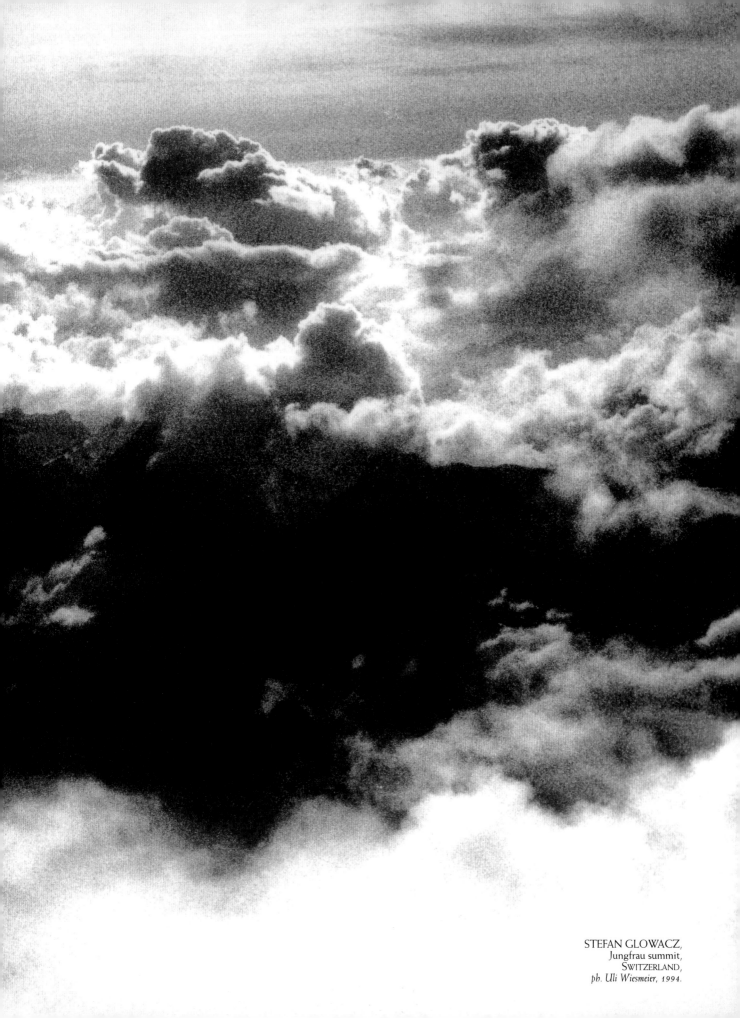

STEFAN GLOWACZ,
Jungfrau summit,
SWITZERLAND,
ph. Uli Wiesmeier, 1994.

equipment
attrezzi
les outils
ausrüstung
material

EQUIPMENT

CRISTIAN BRENNA,
LINO LACEDELLI,
ITALY,
ph. Uli Wiesmeier, 1995.

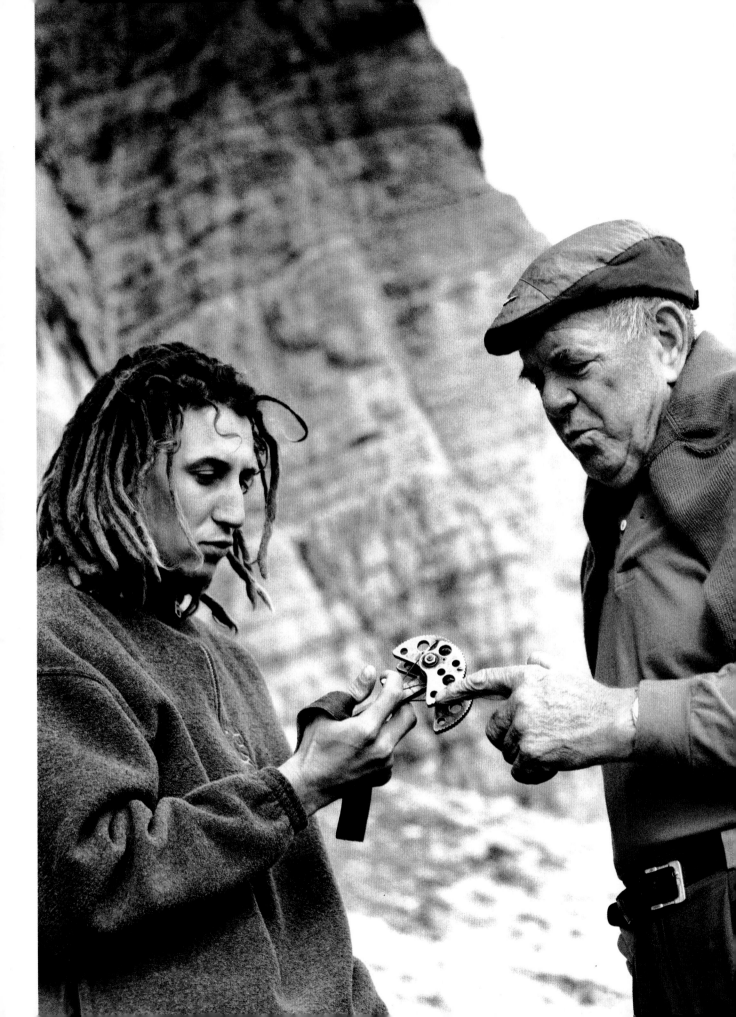

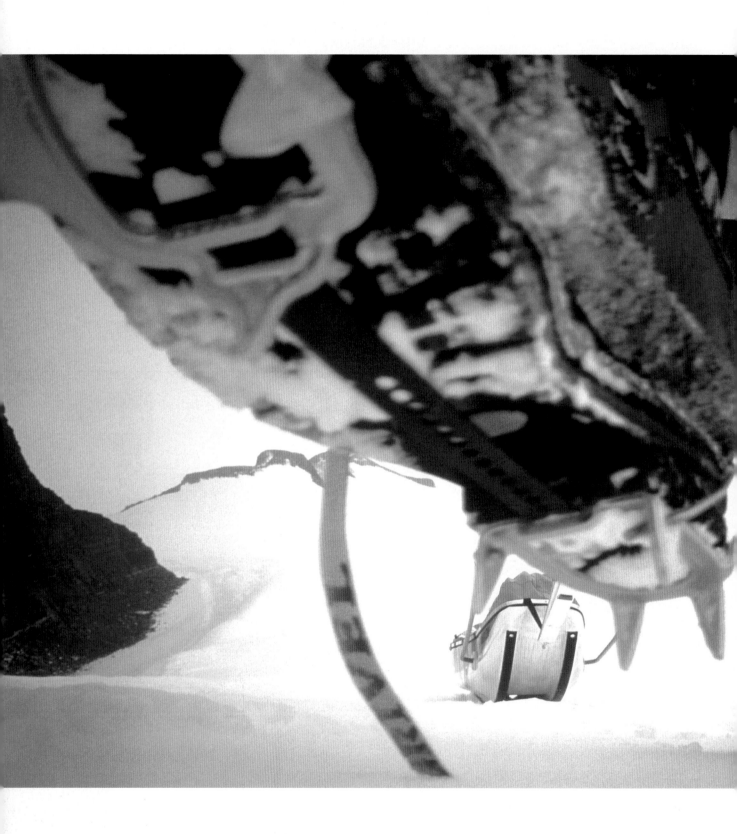

ANTARCTIC
PENINSULA,
ph. Borge Ousland, 1997.

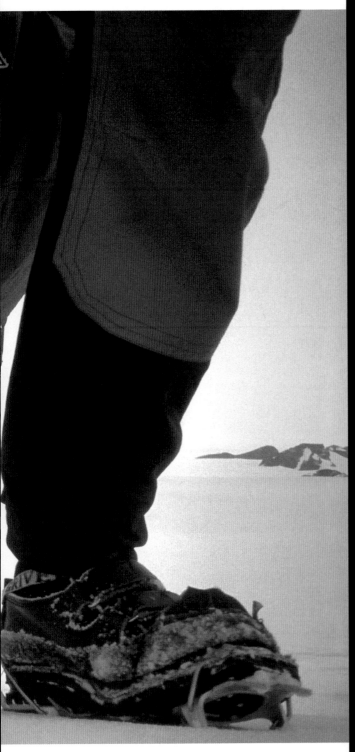

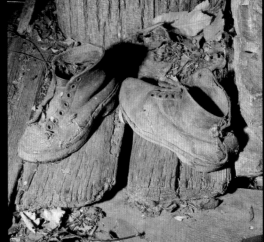

ITALIAN ALPS,
ph. Gianfranco Bini,
1962.

ZANSKAR,
INDIA,
ph. Olivier Föllmi,
1989.

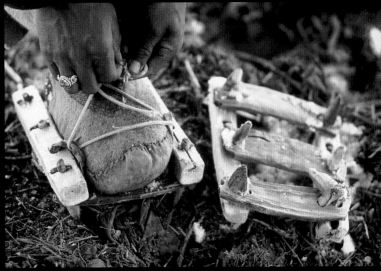

RONDANE
NATIONAL PARK,
NORWAY,
ph. Thomas Ulrich, 1996.

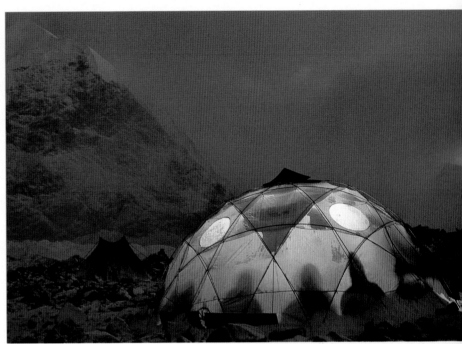

CHO OYU,
Base camp, TIBET,
ph. Philippe Rebreyend, 1997.

INDIAN CREEK
CANYON,
Usa,
ph. Greg Epperson, 1996.

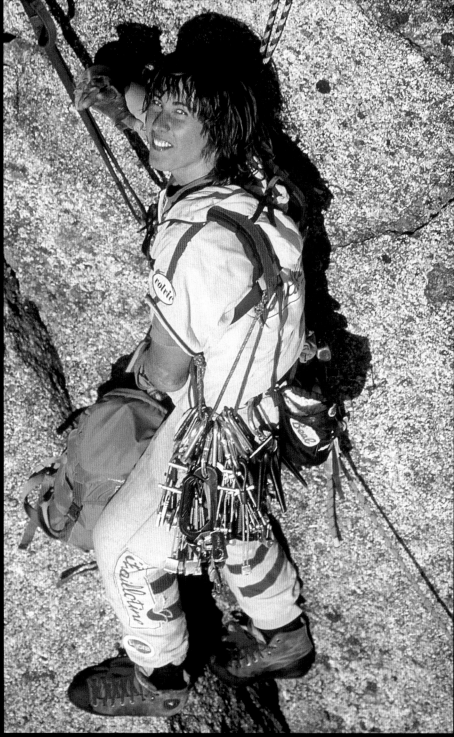

CATHERINE
DESTIVELLE,
Petit Dru,
Mont Blanc, FRANCE,
ph. Sylvie Chappaz, 1991.

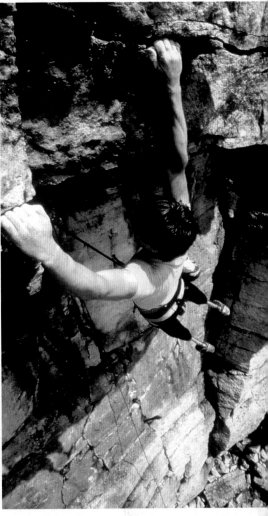

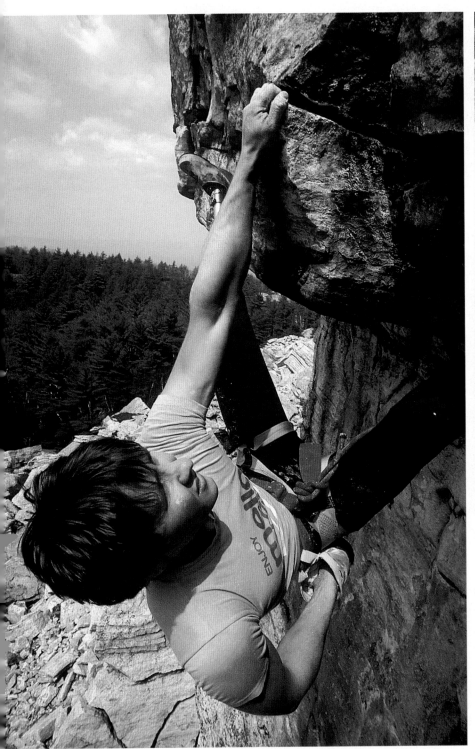

HUGH HERR,
Shawangunks,
USA,
ph. Peter Lewis, 1985.

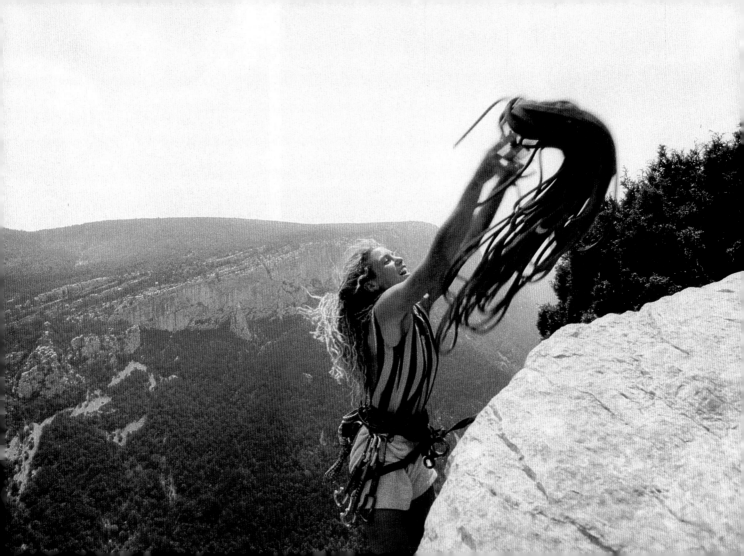

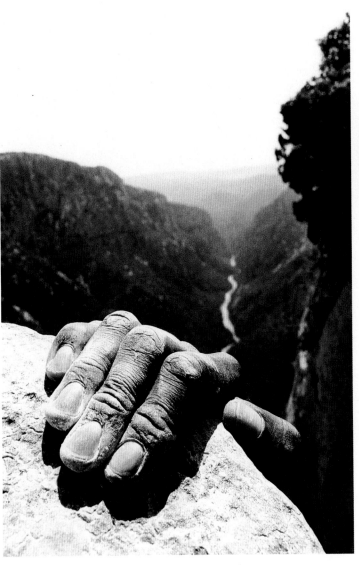

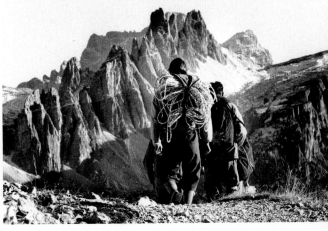

VERDON,
FRANCE,
ph. Wilfried Zwaans, 1994.

DOLOMITES,
ITALY,
ph. Uli Wiesmeier, 1995.

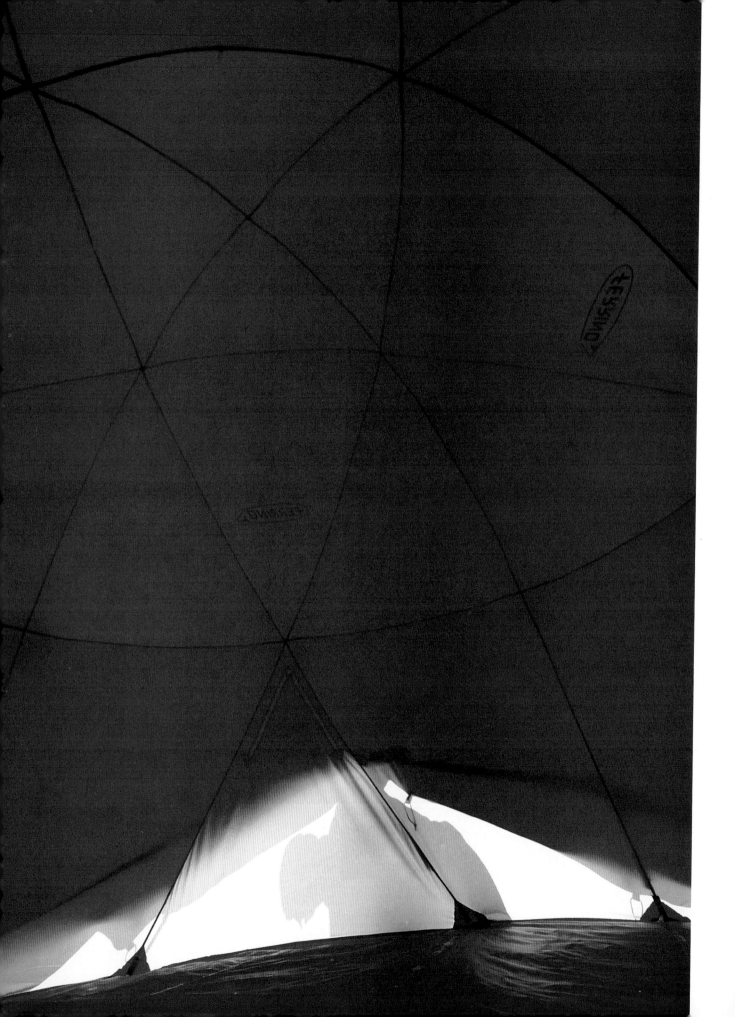

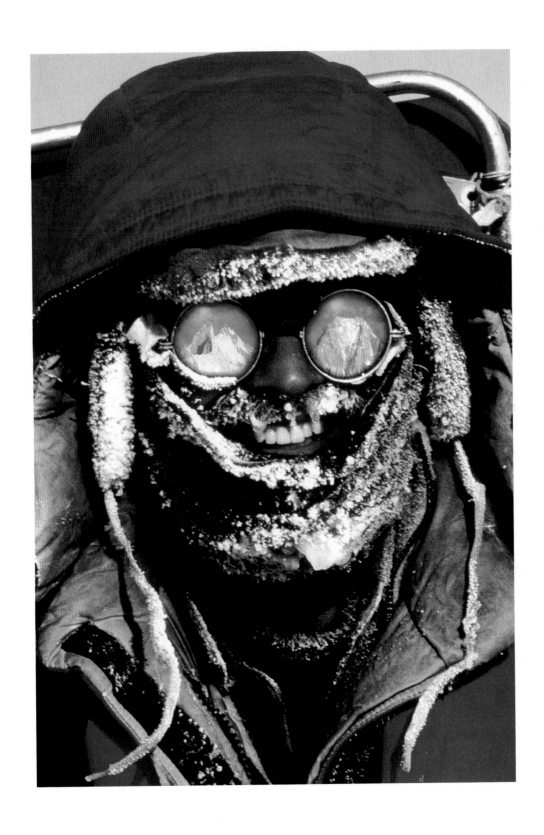

HIMALAYA,
TIBET,
ph. Mario Verin,
1996.

SHERPA,
NEPAL,
ph. Rick Ridgway, 1993.

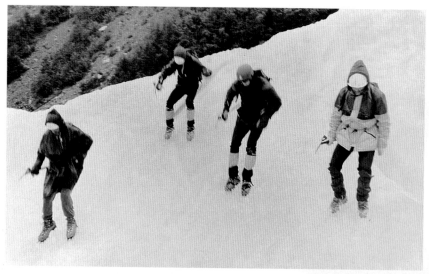

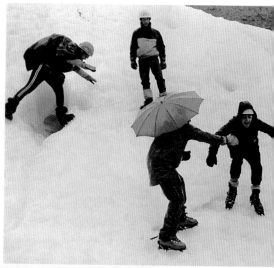

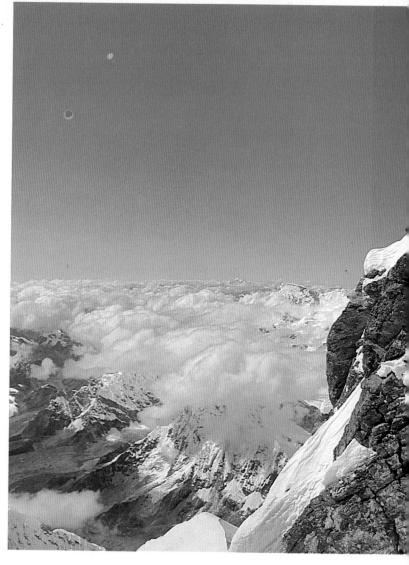

BOSSONS GLACIER,
Mont Blanc, FRANCE,
ph. Guy Martin Ravel, 1987.

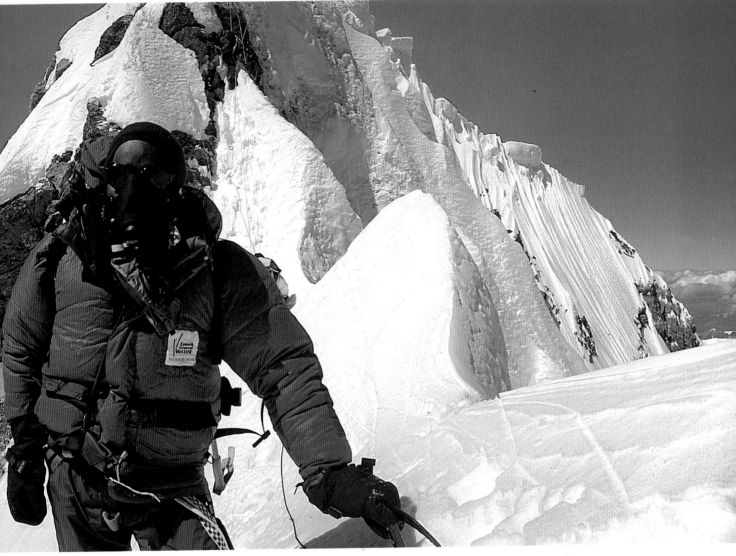

EVEREST,
Nepal,
ph. Jean Michel Asselin, 1992.

life
vita
la vie
leben
vida

MAURIENNE,
FRANCE,
ph. Gianluca Boetti, 1995.

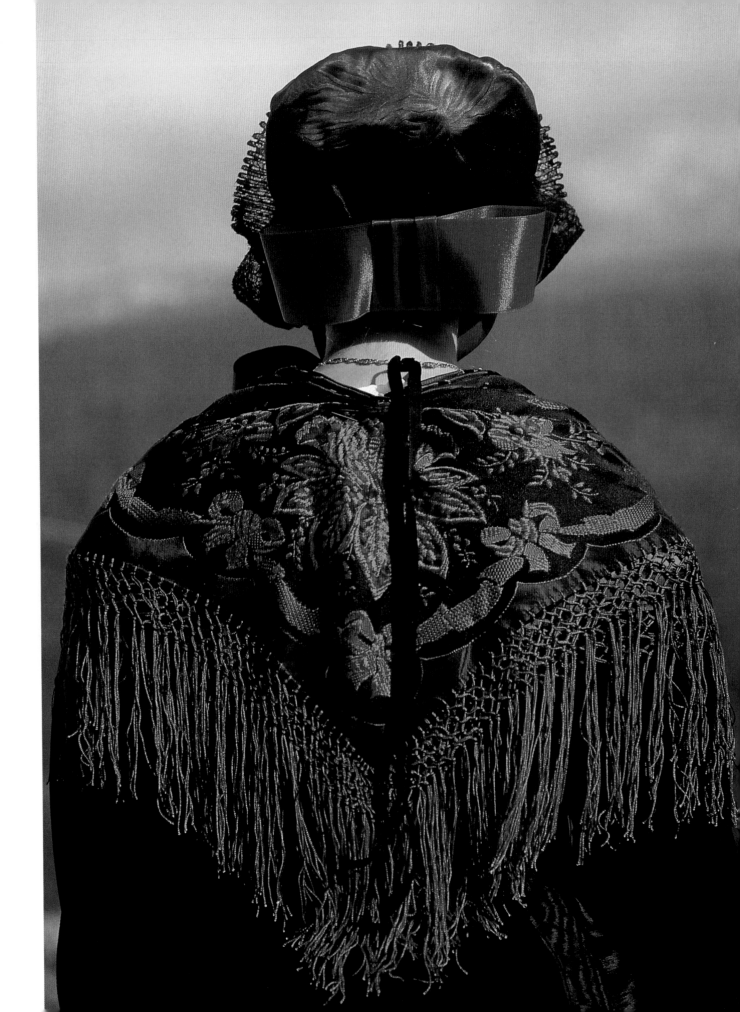

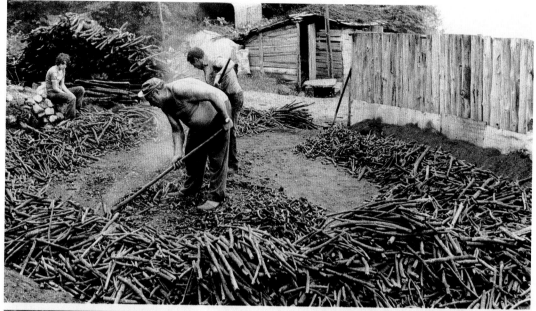

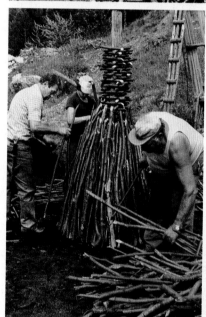

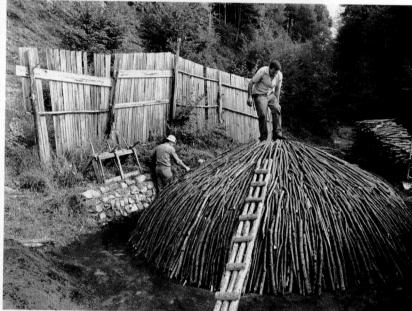

DOLOMITES,
ITALY,
ph. Flavio Faganello,
1984.

MT. CIVETTA,
ITALY,
ph. Marco Scolaris, 1997.

MUSTANG,
ph. Davide Camisasca, 1997.

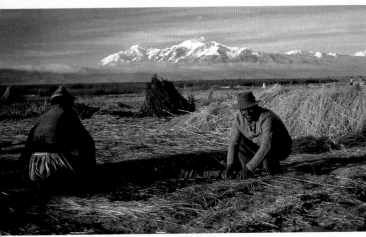

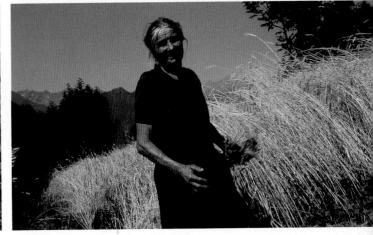

PERU,
ph. Patrick Wagnon, 1996.

AOSTA VALLEY,
ITALY,
ph. Cesare Cossavella, 1986.

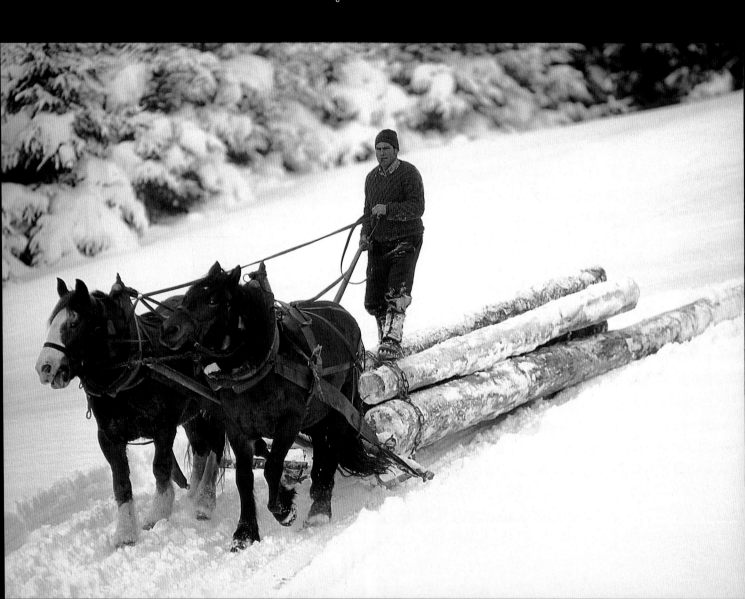

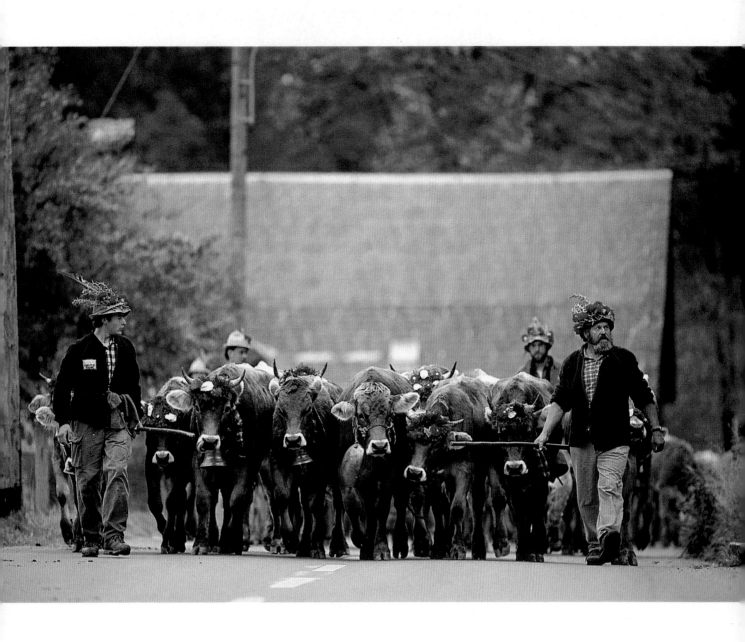

SWISS ALPS,
ph. Peter Mathis, 1994.

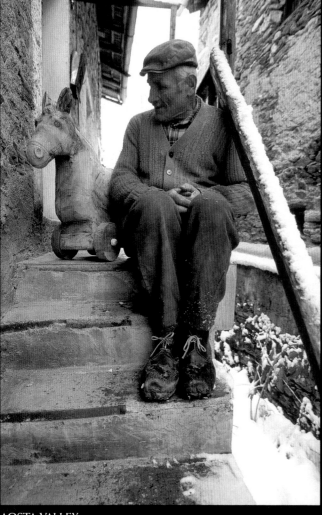

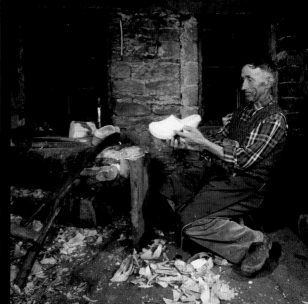

ITALIAN ALPS,
ph. Gianfranco Bini,
1972.

AOSTA VALLEY,
ITALY,

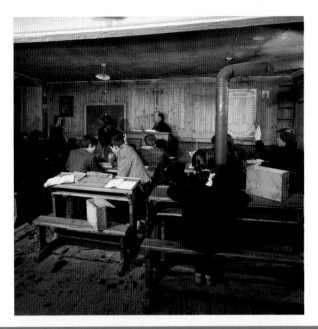

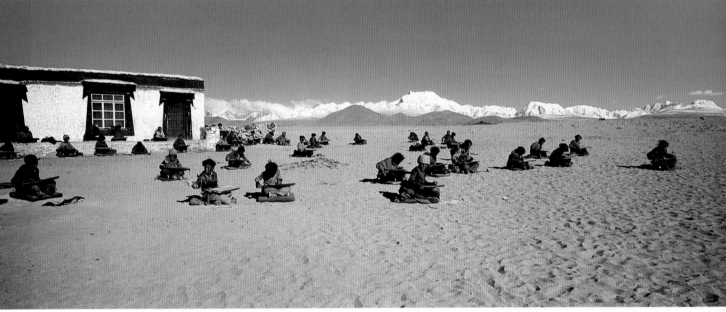

TIBET,
ph. Davide Camisasca,
1994.

ITALIAN ALPS,
ph. Gianfranco Bini,
1960.

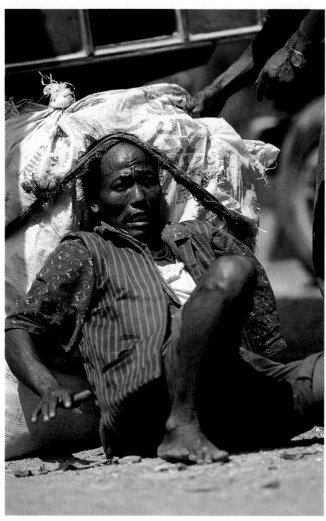

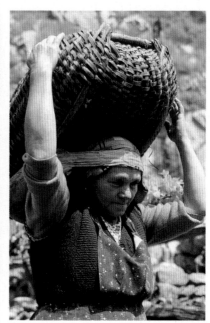

ITALIAN ALPS,
ph. Cesare Cossavella,
1992.

NEPAL,
ph. Philippe Rebreyend, 1996.

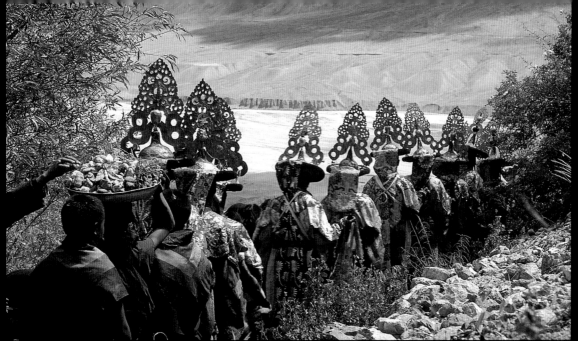

SPITI VALLEY,
INDIA,
*ph. Andrea Alborno,
1993.*

ITALIAN ALPS,
*ph. Andrea Alborno,
1992.*

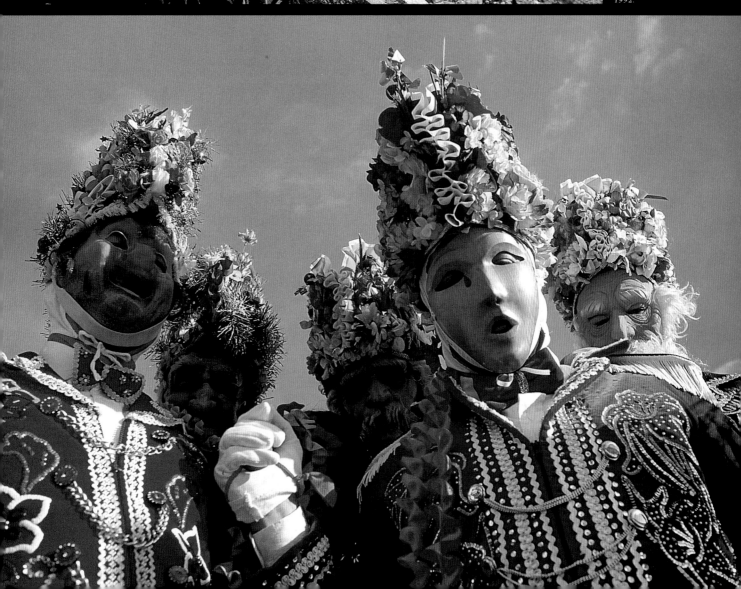

chaos
caos
chaos
chaos
caos

CHA
OS

EVEREST,
South Col, NEPAL,
ph. Robert Bösch, 1990.

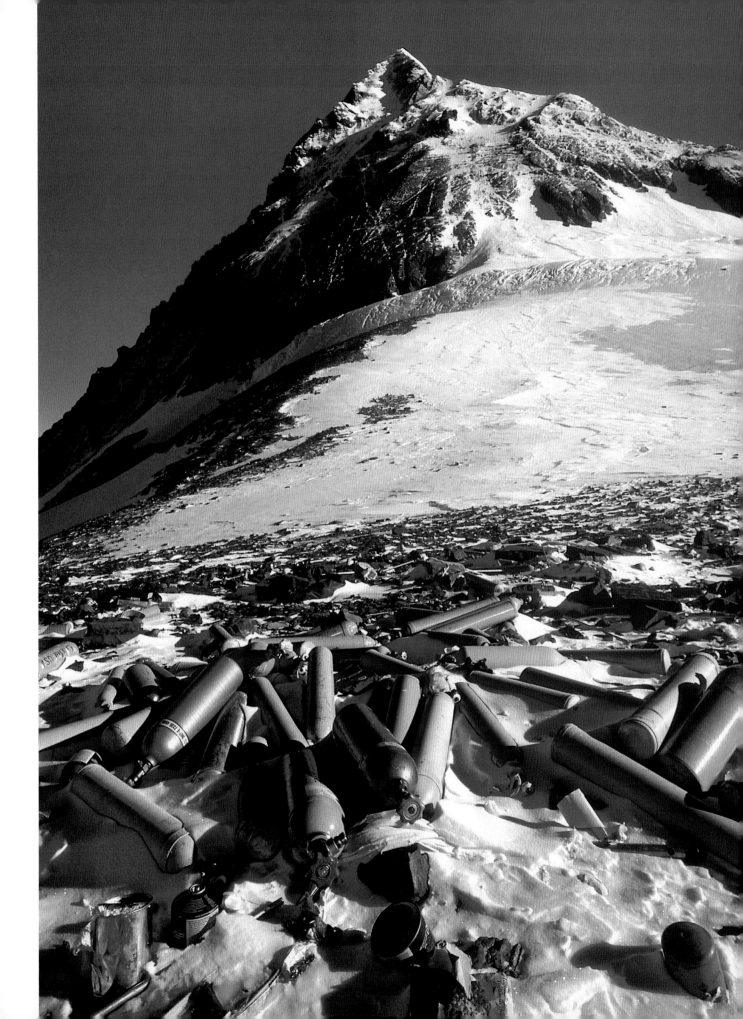

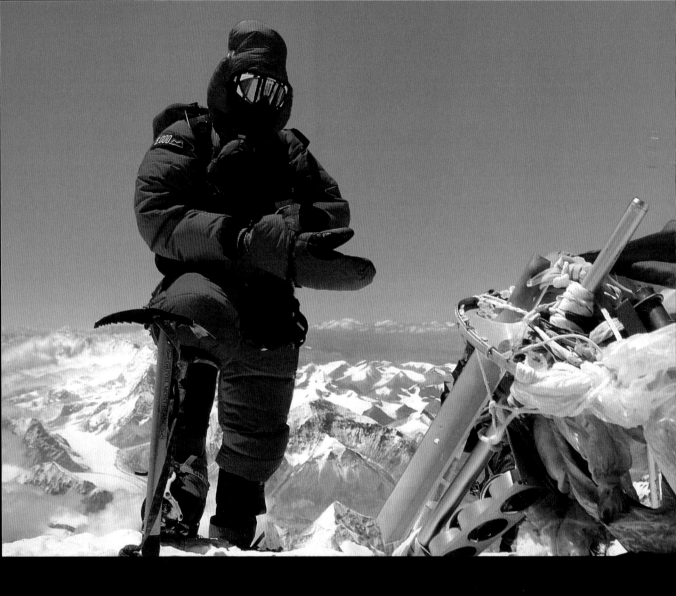

EVEREST,
Summit,
NEPAL,
ph. Hallgrimur Magnusson, 1996.

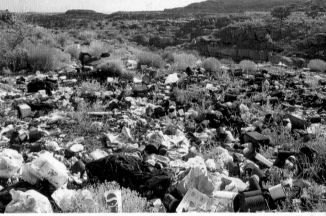

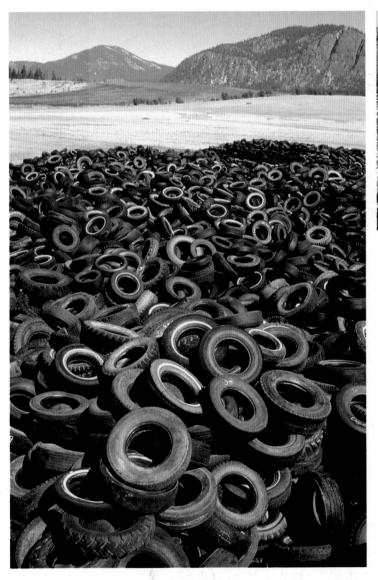

USA,
ph. Peter Arnold, 1982.

MONUMENT VALLEY,
USA,
ph. Livio M. Sinibaldi, 1989.

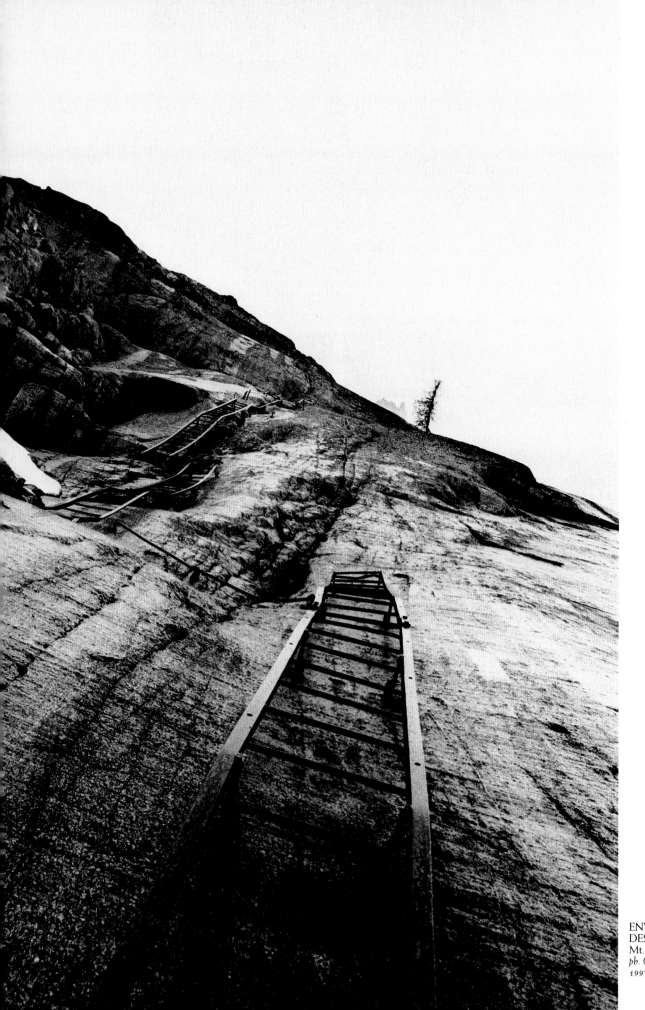

ENVERS
DES AIGUILLES,
Mt. Blanc, FRANCE,
ph. Christophe Bersoullé,
1997.

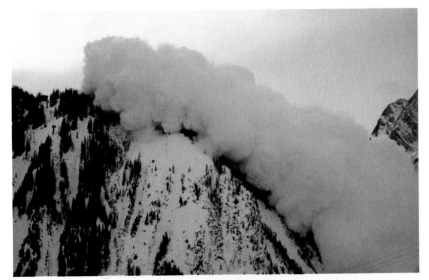

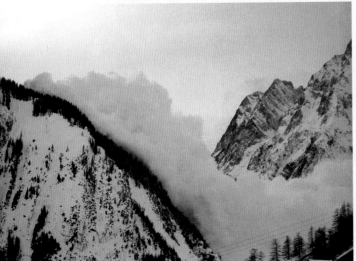

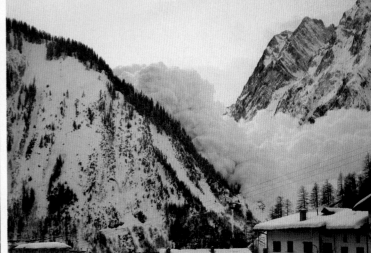

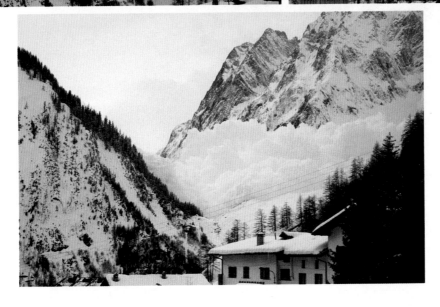

BRENVA GLACIER,
Mont Blanc, ITALY,
ph. Maurizio Fonte, 1997.

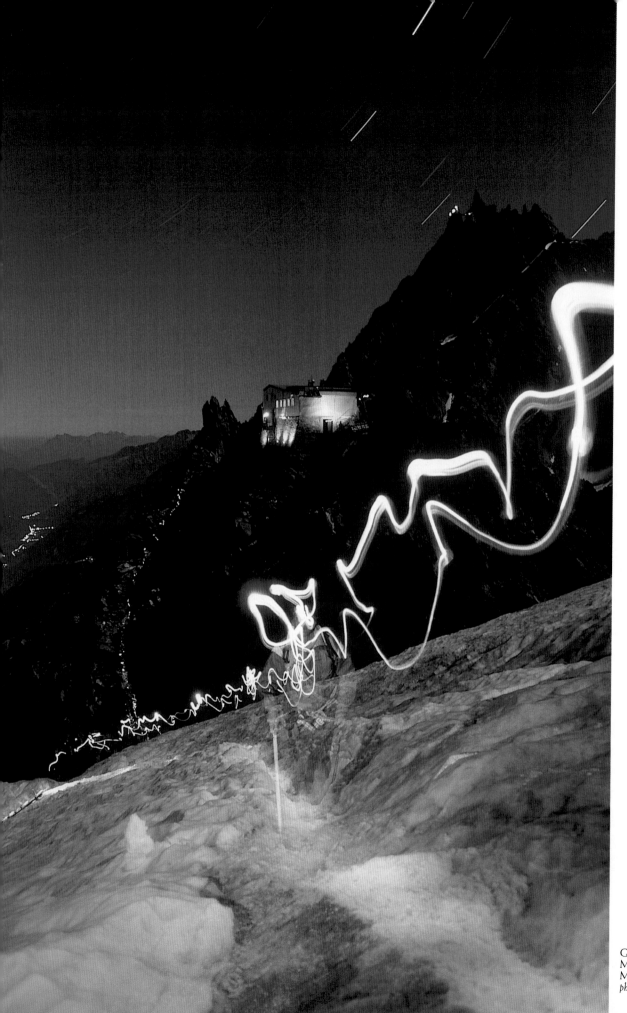

GRANDS
MULETS,
Mont Blanc, FRANCE,
ph. Mario Verin, 1990.

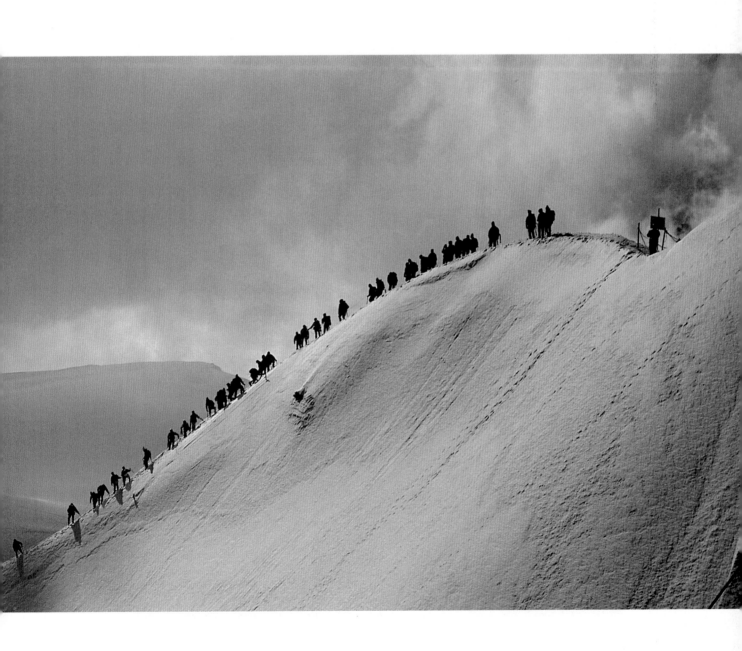

FRENCH ALPS,
ph. Claude Gardien, 1993.

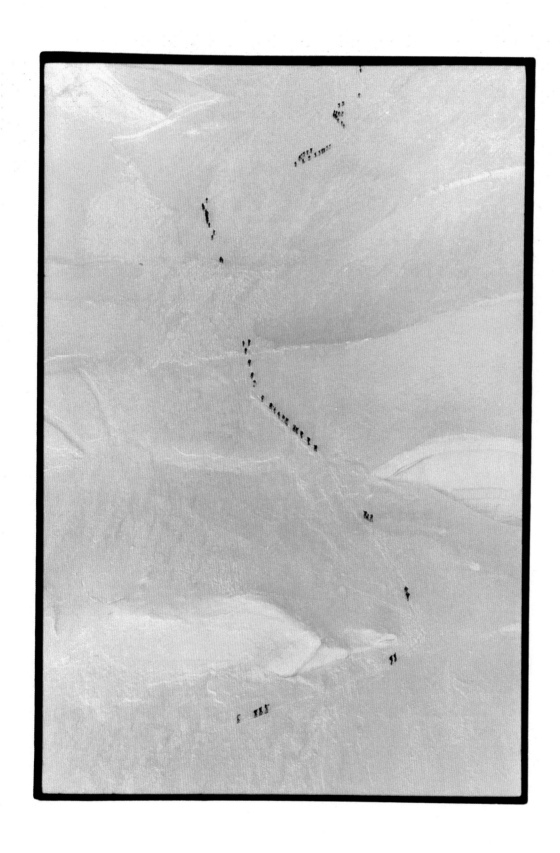

MONT BLANC,
FRANCE,
ph. Guy Martin Ravel, 1987.

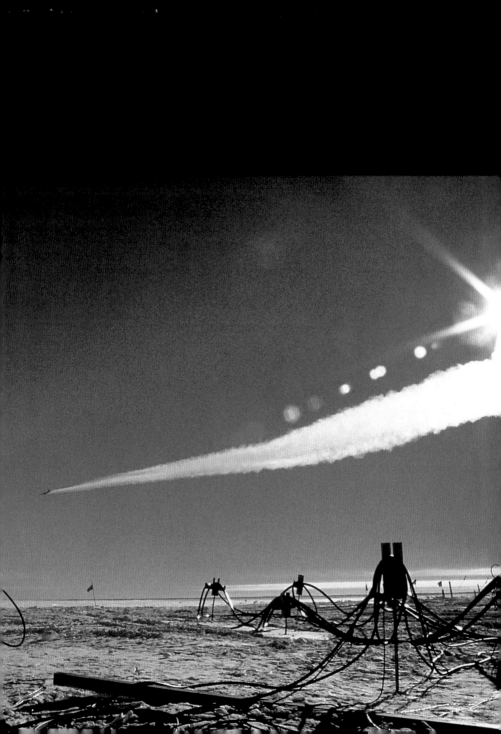

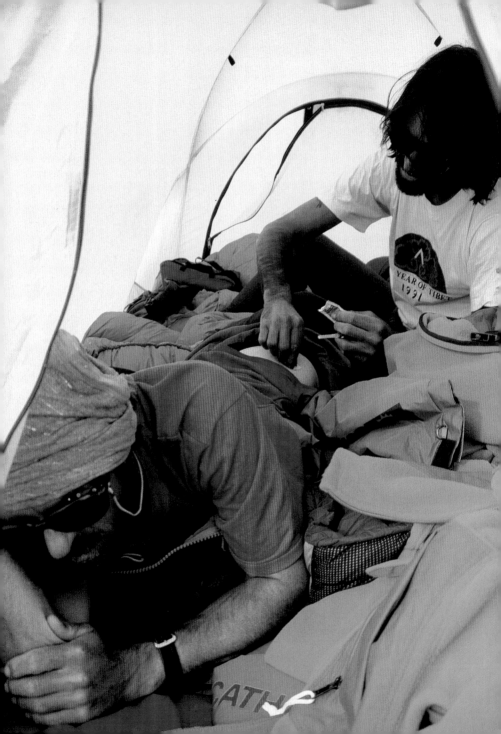

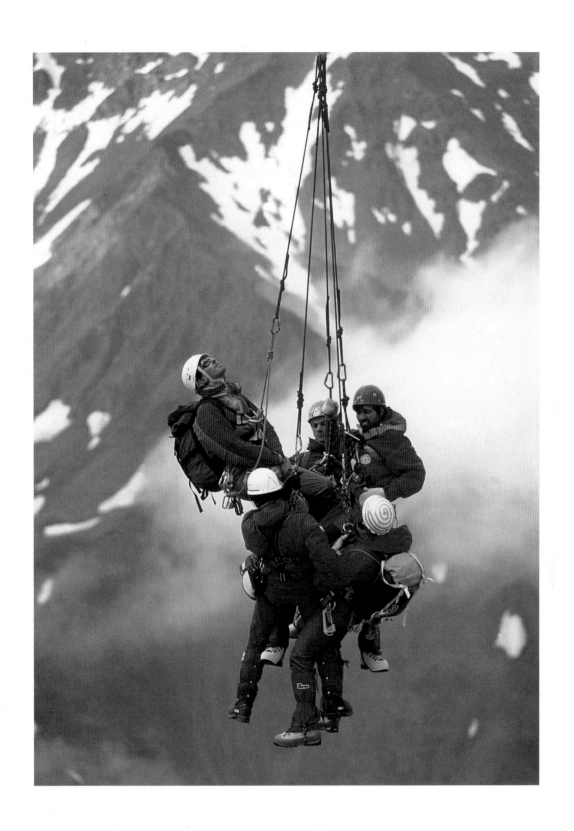

MONT BLANC,
ITALY,
ph. Gianluca Boetti, 1992.

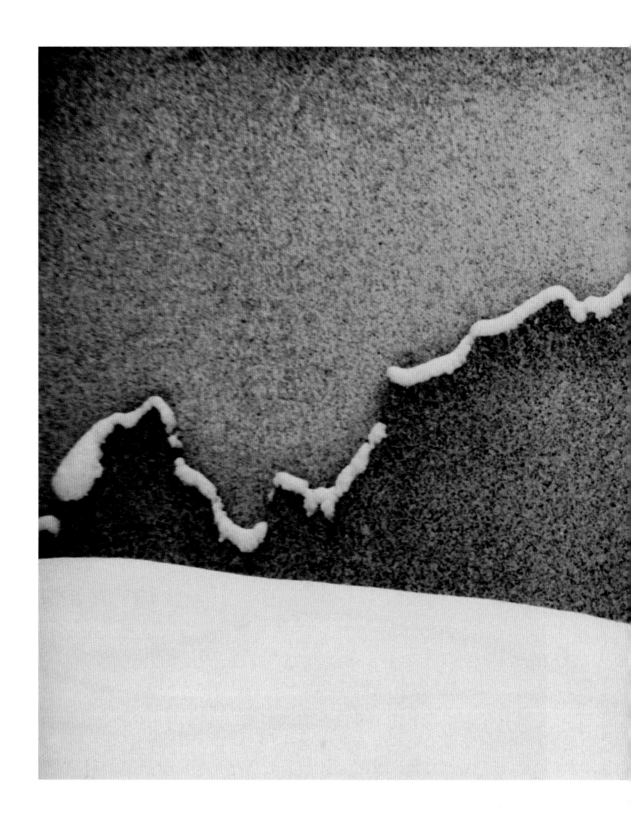

COURMAYEUR,
ITALY,
ph. Manuel Mateus Ratera, 1980.

spirit
spirito
esprit
esprit
espíritu

AMA DABLAM,
NEPAL,
ph. Heinz Zak, 1994.

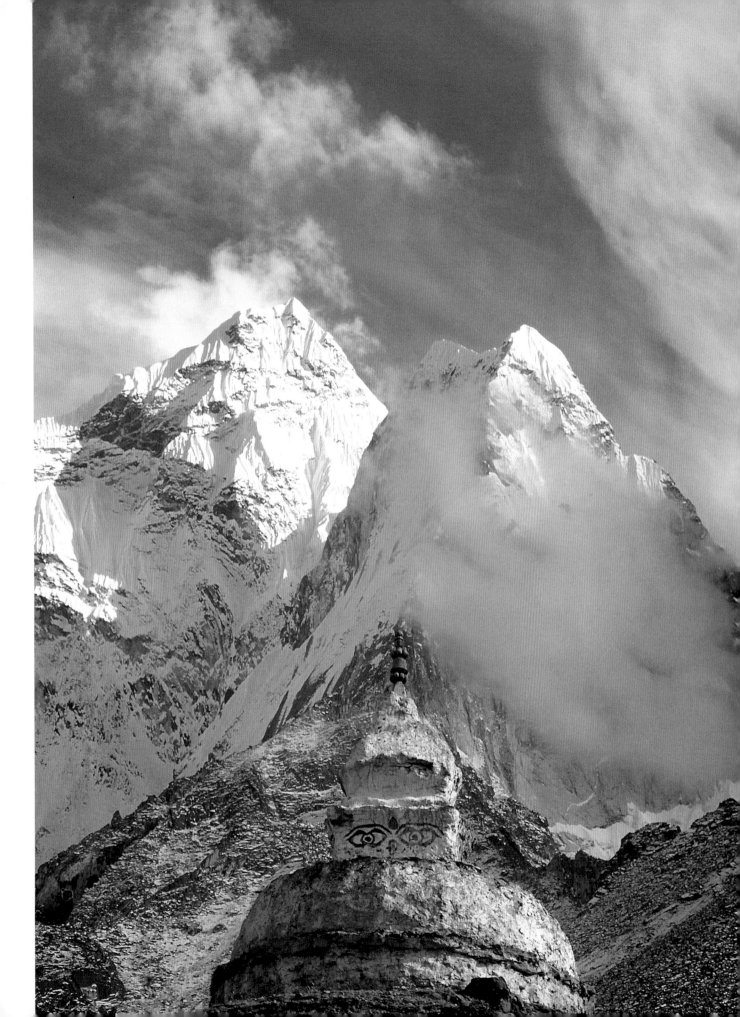

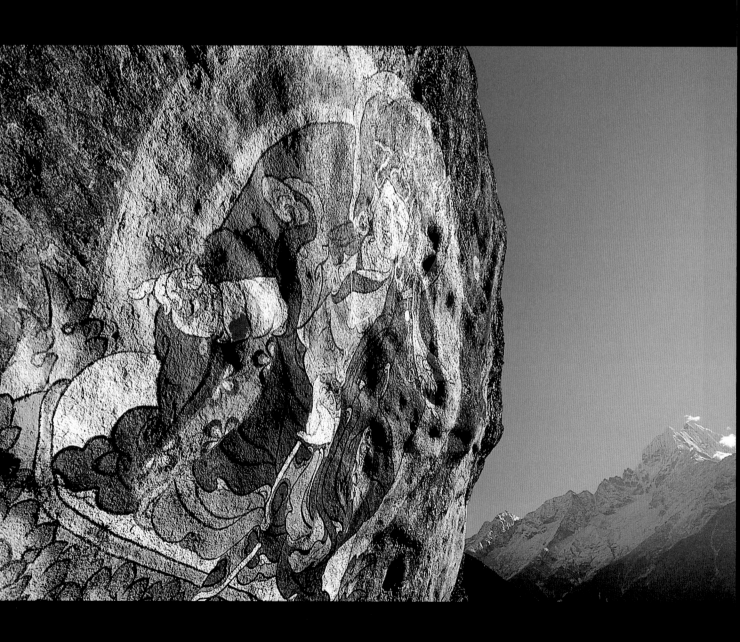

NEPAL,
ph. Heinz Zak, 1994.

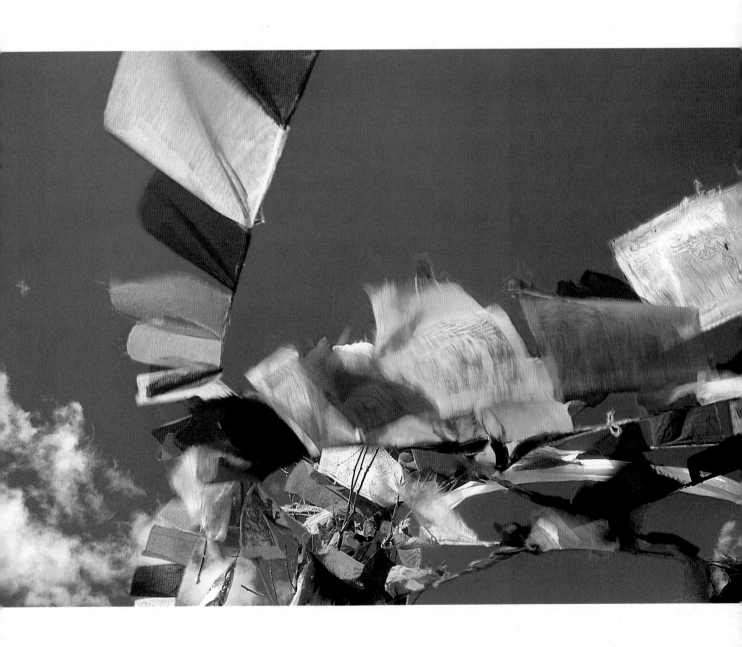

Tibet,
ph. Philieppe Rebreyend, 1997.

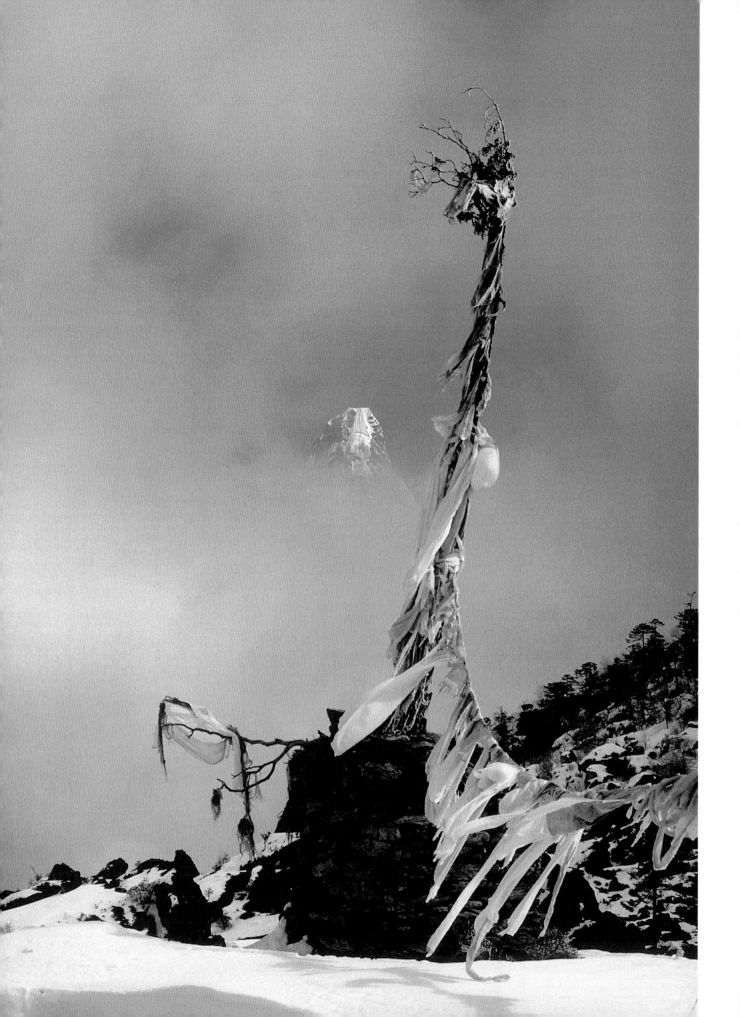

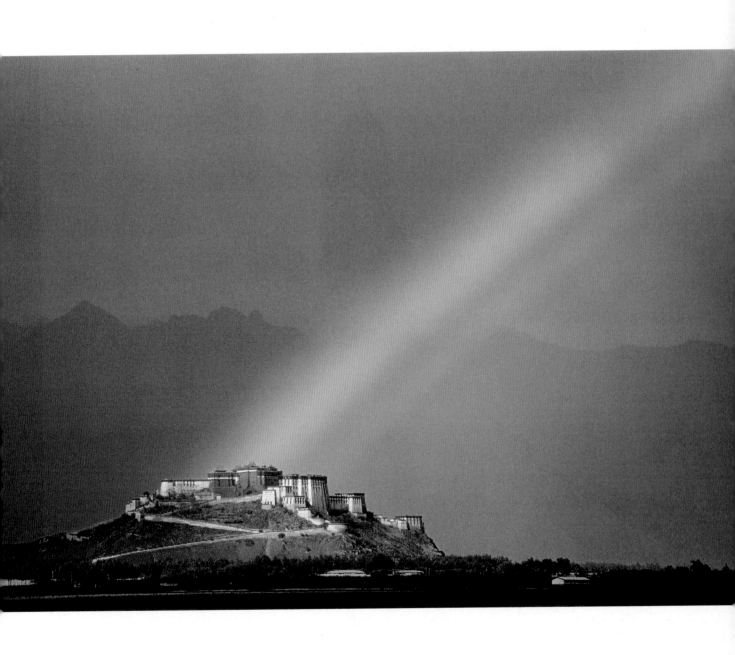

AMA DABLAM,
NEPAL,
ph. Robert Bösch, 1988.

LHASA,
TIBET,
ph. Galen Rowell, 1989.

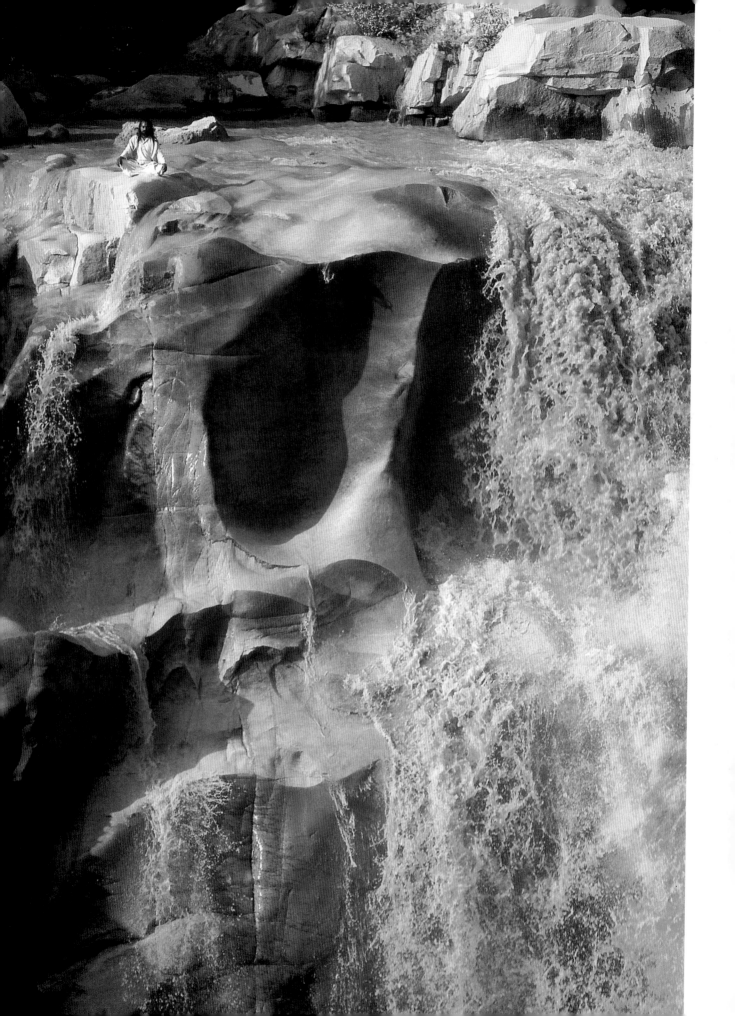

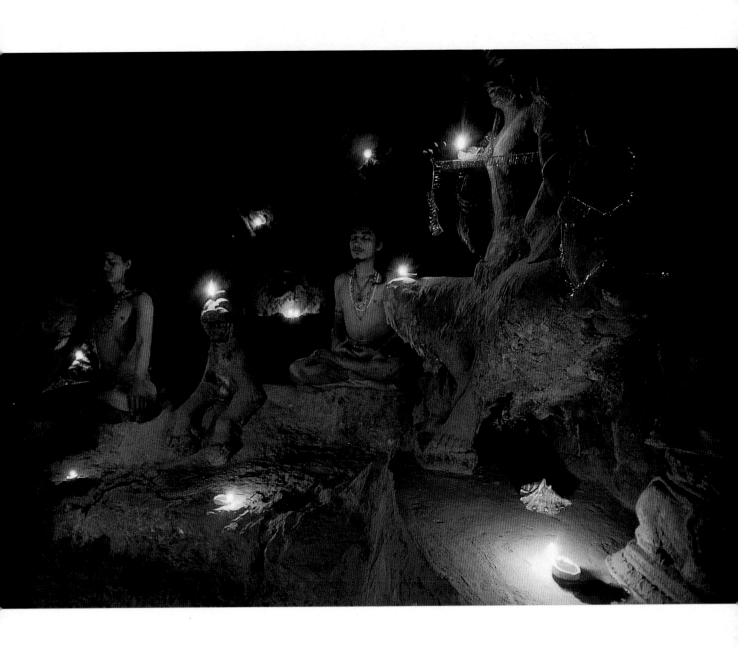

GANGOTRI,
INDIA,
ph. Andrea Alborno, 1996.

RISHIKESH,
INDIA,
ph. Andrea Alborno, 1996.

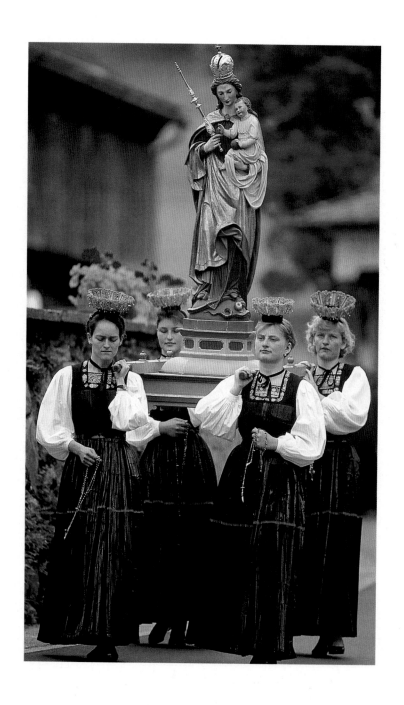

AUSTRIA,
ph. Peter Mathis, 1993.

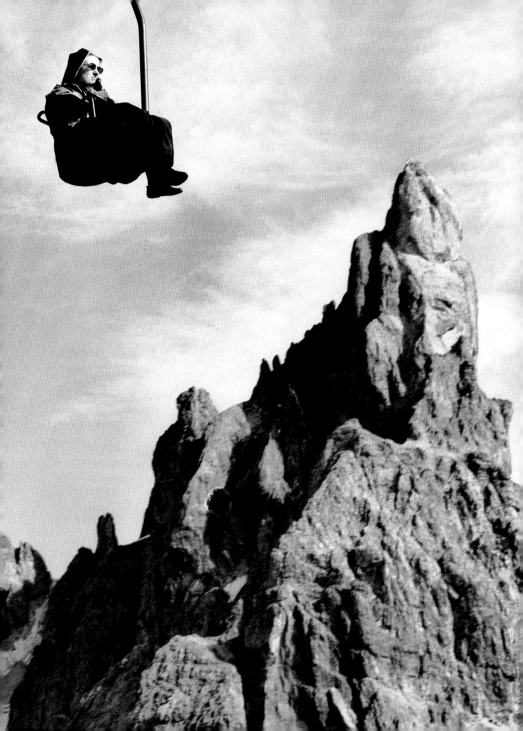

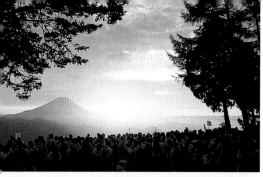

MT. FUJI,
JAPAN,
ph. Pat Morrow,
1995.

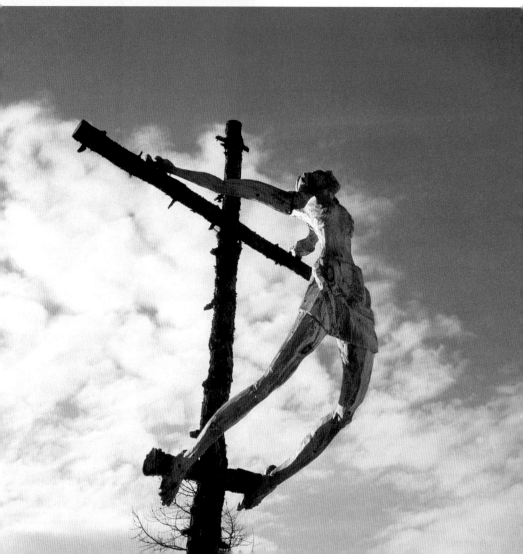

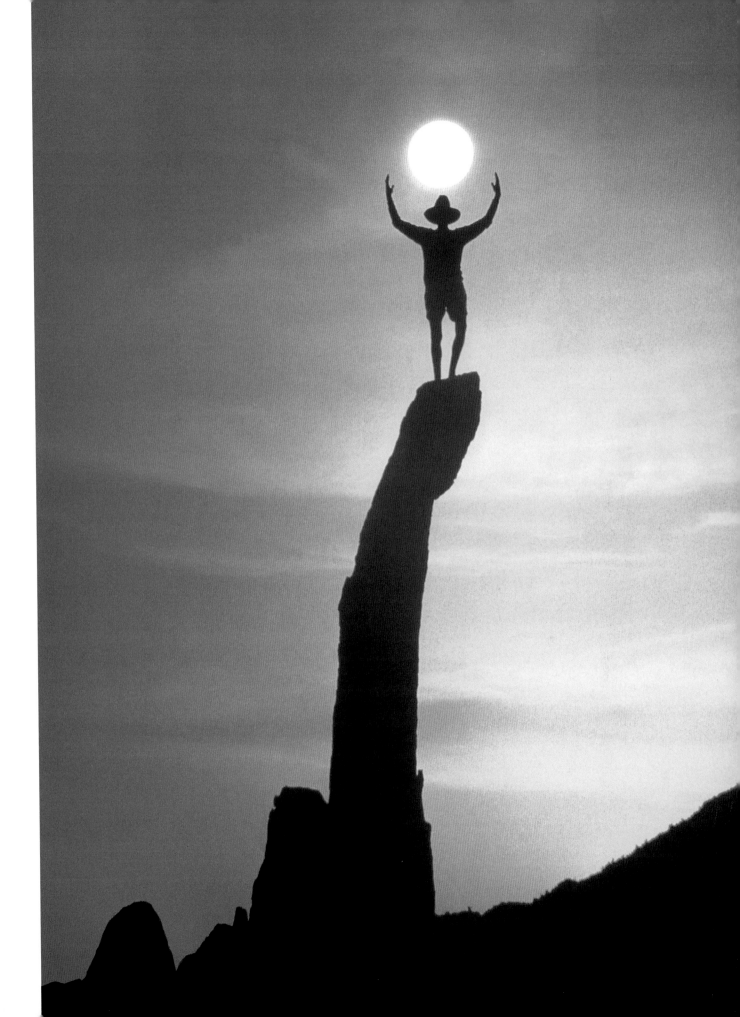

lights
luci
lumières
licht
luces

LIG
HTS

PUMORI,
NEPAL,
ph. Xavier Murillo, 1987.

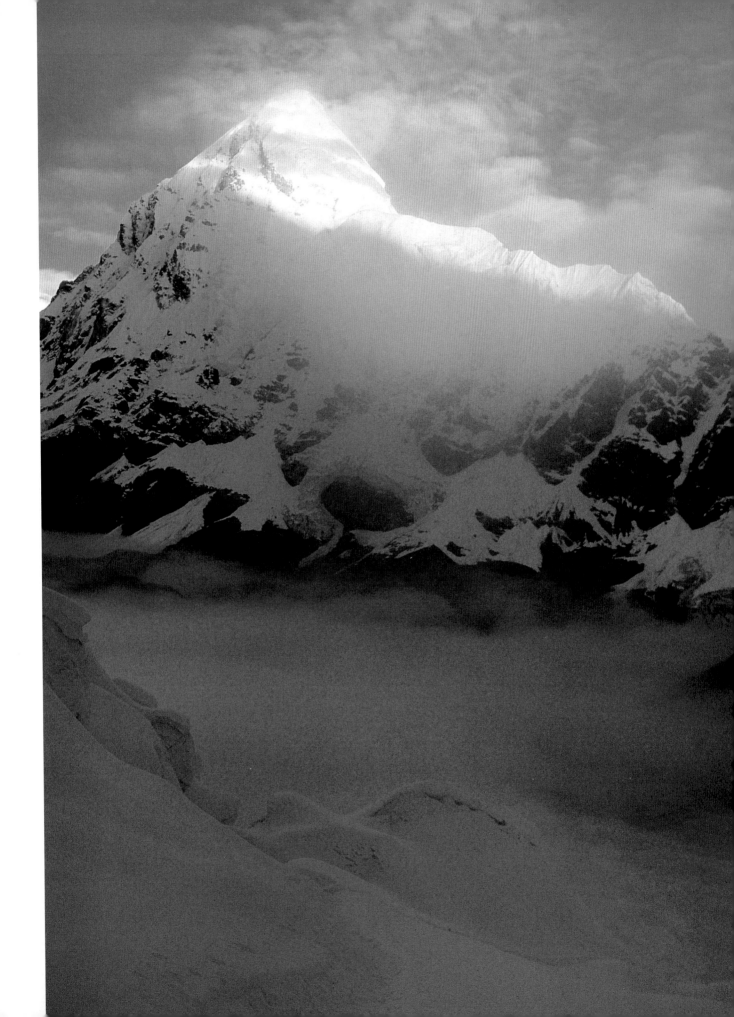

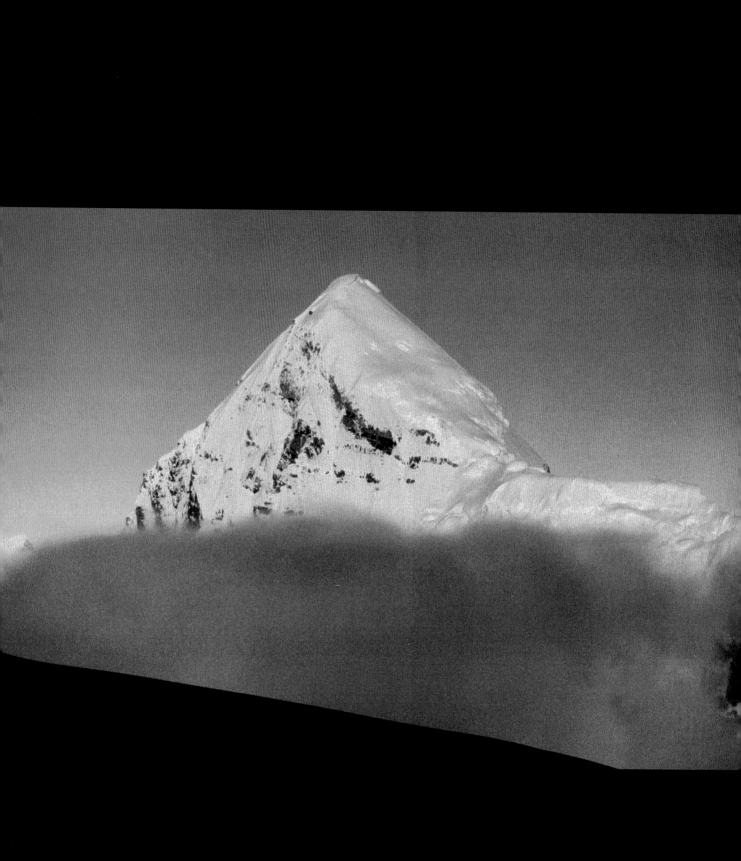

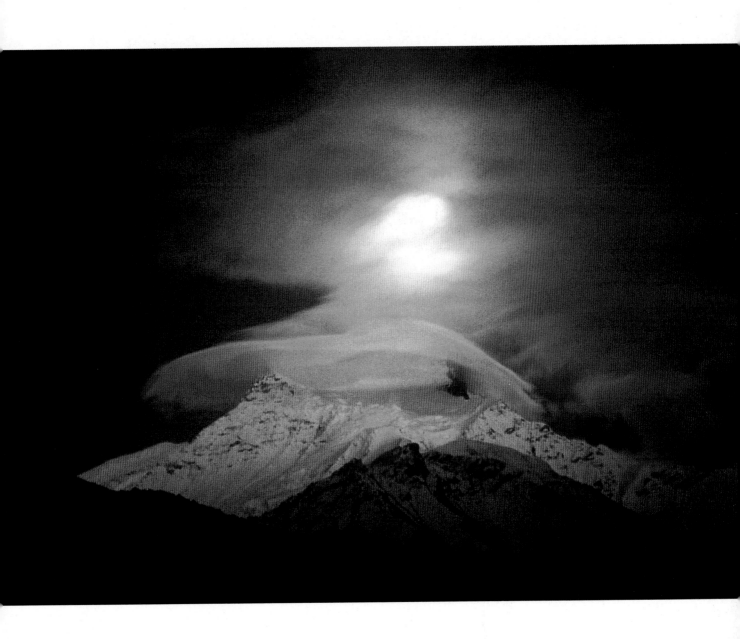

PUMORI,
NEPAL,
ph. Pat Morrow, 1987.

CHO OYU,
TIBET,
ph. Sergio De Leo, 1991.

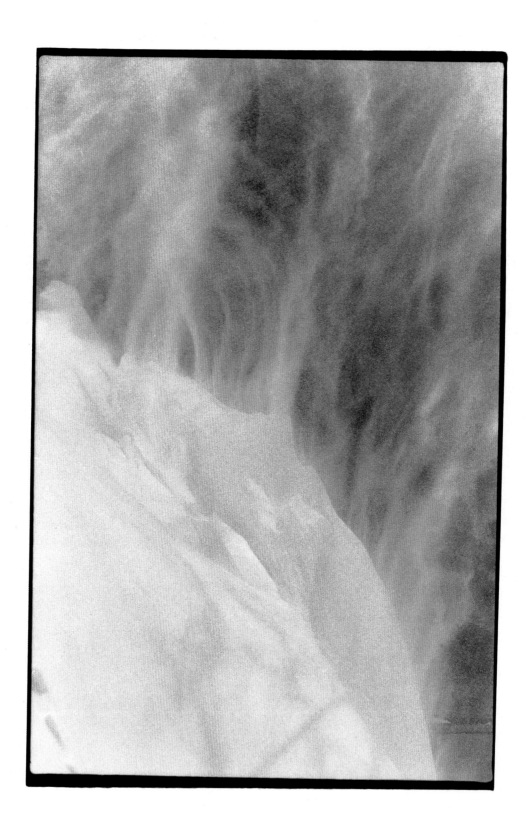

VERCORS,
France,
ph. Guy Martin Ravel, 1988.

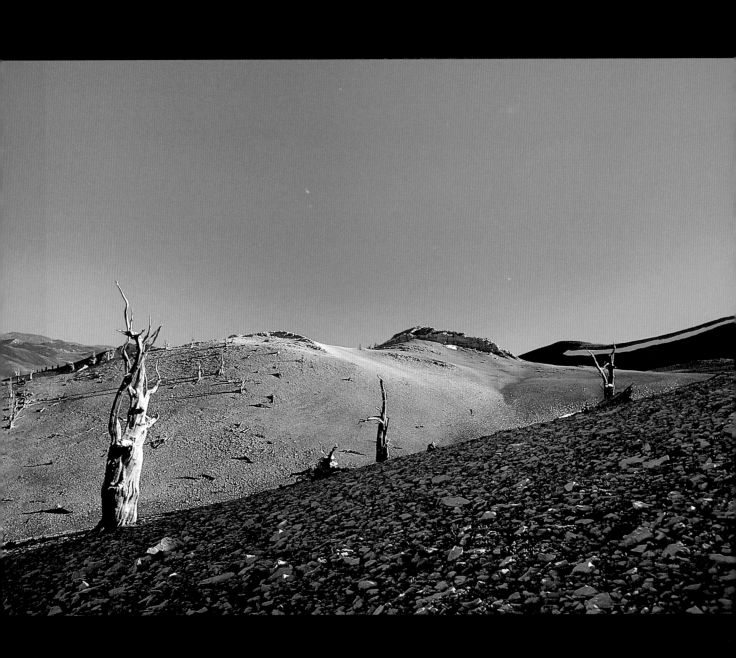

WHITE
MOUNTAINS, Usa,
ph. Marco Scolaris, 1996.

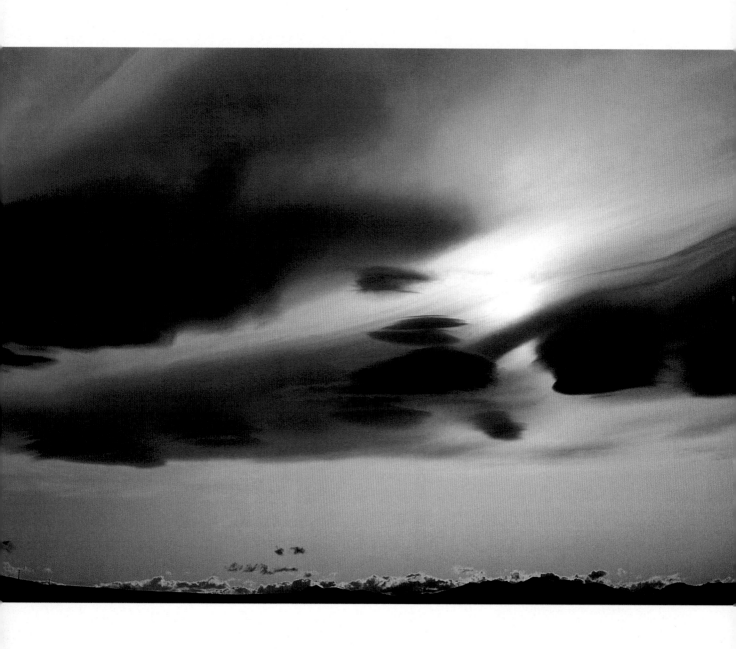

PATAGONIA,
ARGENTINA,
ph. Thomas Ulrich, 1996.

AUSTRIAN ALPS,
ph. Peter Mathis, 1992.

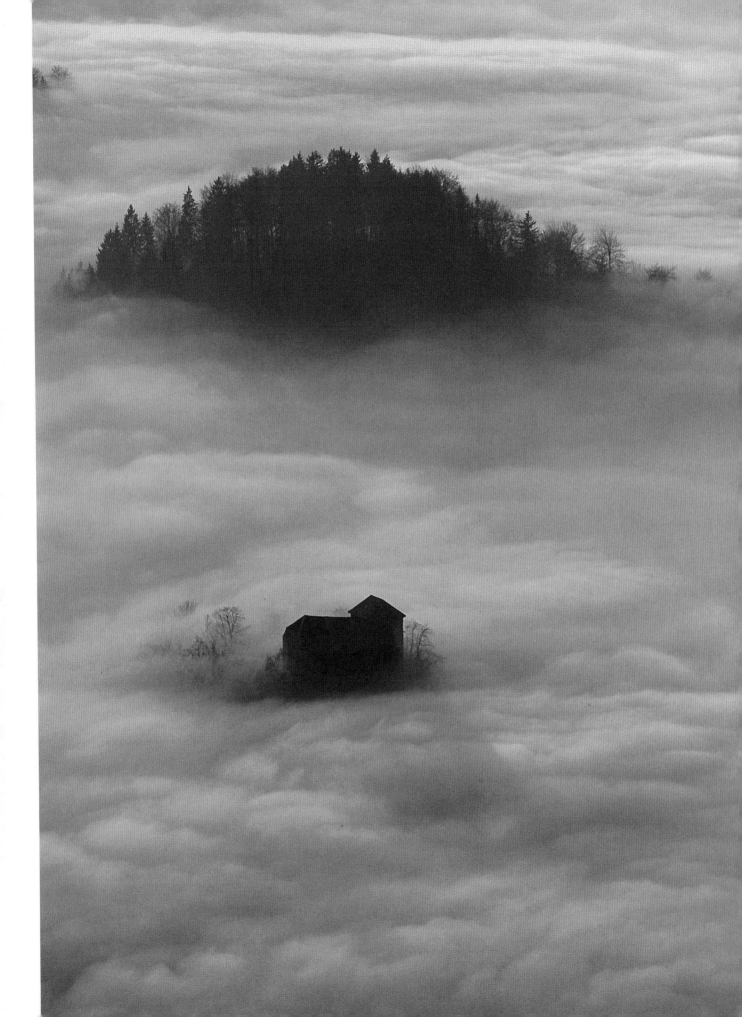

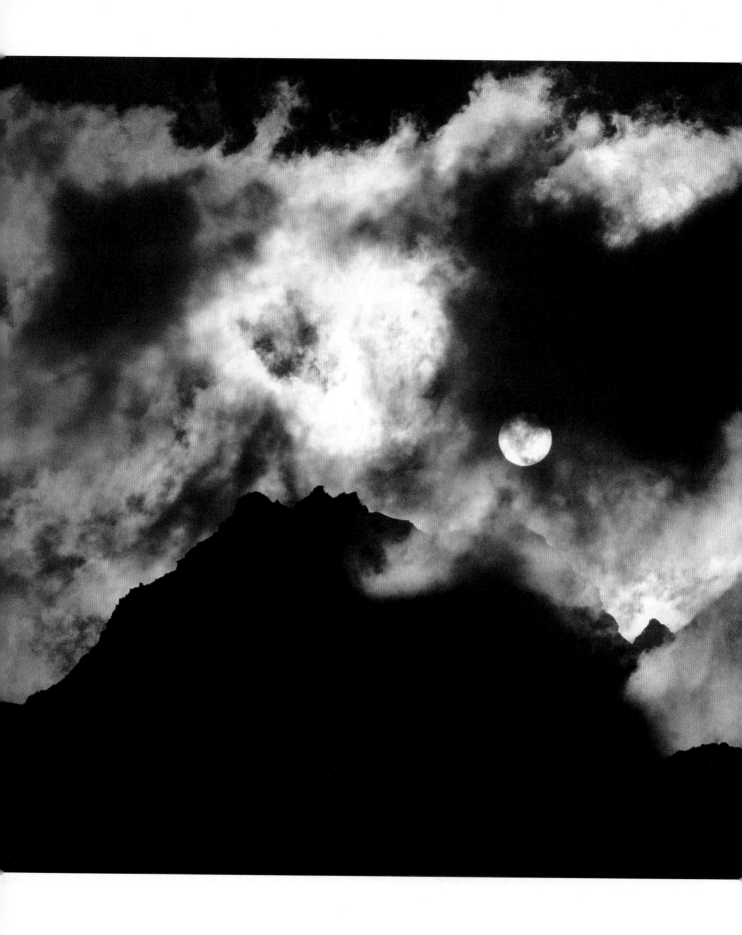

SPITI VALLEY,
INDIA,
ph. Andrea Alborno, 1993.

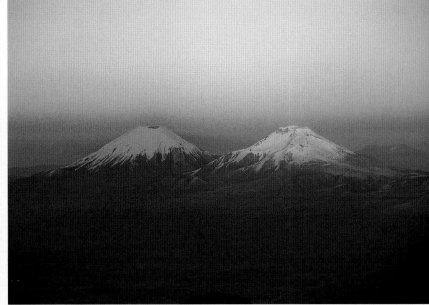

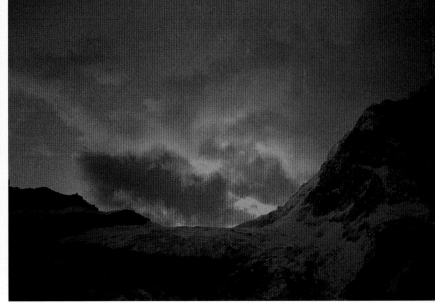

PARINACOTA POMERAPI,
BOLIVIA,
ph. Patrick Wagnon, 1996.

HUANDOY,
PERU,
ph. Jerome Blanc Gras, 1997.

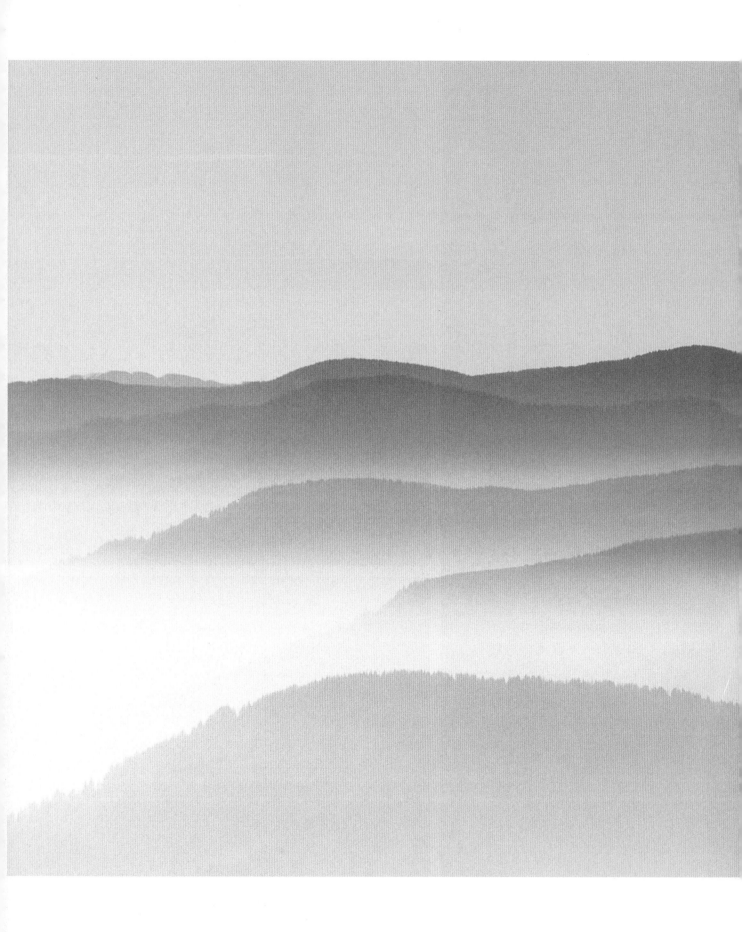

MT. AVENA,
ITALY,
ph. Gian Domenico Vincenzi, 1994.

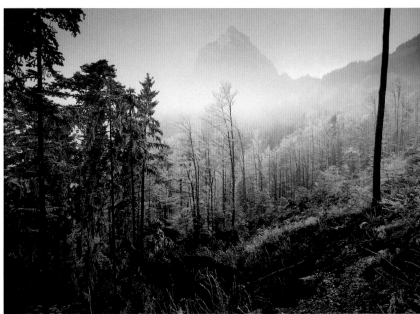

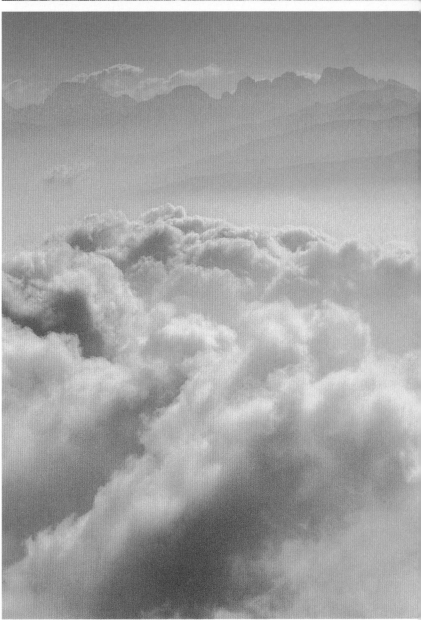

BRENTA,
ITALY,
ph. Gian Domenico Vincenzi,
1998.

SWITZERLAND,
ph. Robert Bösch, 1993.

PHOTO EDITOR
Betta Gobbi

CONCEPT
Gioachino Gobbi

ART DIRECTOR
Eliana Barbera

EDITOR
Marco A. Ferrari
Volker Leuchsner (klettern)
Jean-Mi Asselin (Vertical)

PHOTOLITHOGRAPHY
Studio PRO srl, Torino

PRINTED BY
G. Canale & C. spa, Torino

Published by
Vivalda Editori srl

COPYRIGHT
© Vivalda Editori srl, 1998

Yearly Publication
Pubblicazione annuale

Andrea Alborno
Loc. Rosselin
11020 Gressan (AO)
Italy
Phone: 0165-59936

Arnold Peter/Franca Speranza
Via Melzo, 9
20129 Milano
Italy
Phone: 02-29402599
Fax: 02-29413847

Asselin Jean Michel
38660 La Batie
St. Bérnard du Touvet
France
Phone: 04-76-887588
Fax: 04-76-887589

Berger Max
c/o A. Kaufmann
Schwimmschulstr. 18
5020 Salzburg
Austria
Phone: 0662-824987
Fax. 0662-8249873

Bersouilé Christophe
55, rue du télégraphe
75020 Paris
France
Phone & Fax: 01-43150104

Bini Gianfranco
Via Italia 22
13900 Biella
Italy
Phone & Fax: 015-23367

Blanc Gras Jérome
Saint-Alban
05380 Chateauroux les Alpes
France
Phone & Fax: 0492-451878

Boetti Gianiuca
Via Trieste, 28 bis
10017 Montanaro (TO)
Italy
Phone & Fax. 011-9192172

Bösch Robert
Morgartenstr. 20
6315 Oberageri
Switzerland
Phone: 041-7505755
Fax: 041-7500155

Bouvet Laurent/Rapsodia
1548, Av. Marcel Dassault
74370 Argonay
France
Phone: 04-50-272165
Fax: 04-50-271464

Camisasca Davide
P.zza Umberto I, 9
11025 Gressoney (AO)
Italy
Phone: 0125-355403

Chappaz Sylvie
15/17 Chemin de la Capuche
38100 Grenoble
France
Phone & Fax: 0476-460898

Cossavella Cesare
Fraz. Ville, 26
11020 Arnad (AO)
Italy
Phone: 0125-969978

Cosson Renzino
Via Grandes Jorasses, 14
11013 Courmayeur
Italy
Phone: 0165-89336

De Leo Sergio
C.so Ivrea, 81
11100 Aosta
Italy
Phone: 0165-361588
Fax: 0165-364520

Decamp Erik
Les Chavaux
74310 Les Houches
France
Phone: 0450/545923124

Epperson Greg
543 Sierra Street
Bishop, California 93514
U.S.A.
Phone: 0760/8724759
Fax: 0760/8721563

Faganello Flavio
Via Serafini, 9
38100 Trento
Italy
Phone. 0461/234539

Fonte Maurizio
Via Pascal
11010 Pré St. Didier (AO)
Italy
Phone: 0165/846279

Föllmi Olivier/Planet Agency
10, rue Royale
75008 Paris
France
Phone: 0155359767
Fax: 0155359766

Gabarrou Patrick
La Cour Agy
74300 Saint Sigismond
France
Phone & Fax. 0450342485

Gallo Andrea/Idee Verticali
Via Gallesio 11
17024 Finale Ligure (SV)
Italy
Phone & Fax. 019695997

Gardien Claude
558, rue des Chilles
74970 Marignier
France
Phone & Fax: 0450892098

Gobbi Oliviero
Via Marconi, 50
11013 Courmayeur (AO)
Italy
Phone: 0165843714
Fax: 0165844800

Gouault Laurence
Chalet Touze
BP. 32
74310 Les Houches
France

Harvey Kennan
P.O. Box 520772
Salt Lake City, Utah 84152
U.S.A.
Phone & Fax: 0801-3632636

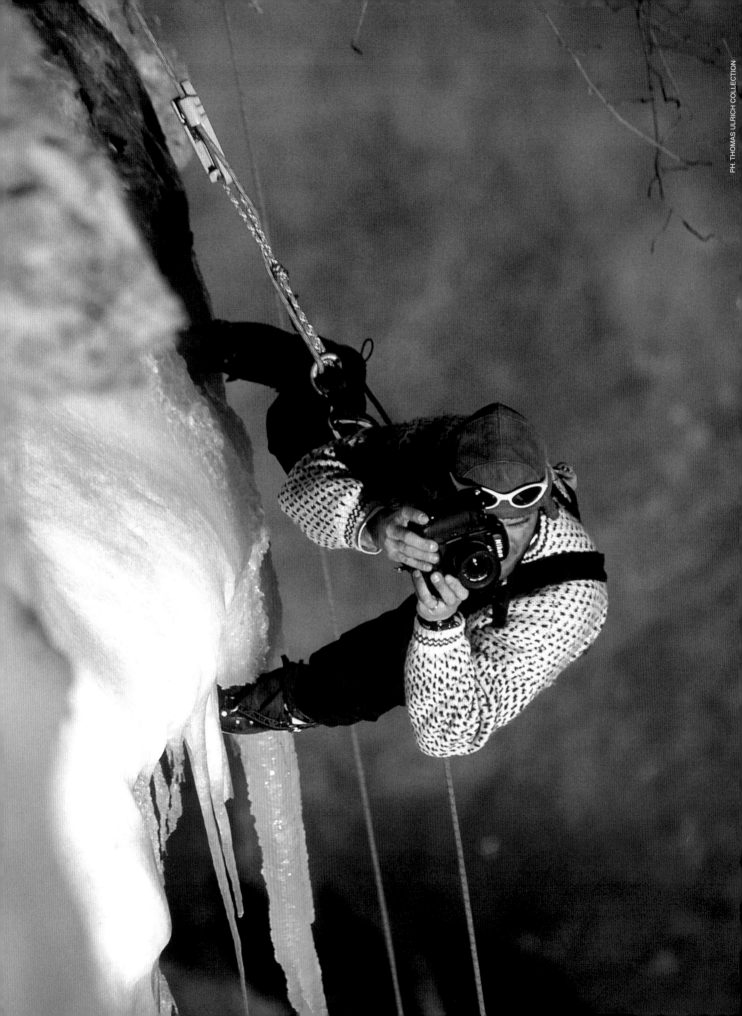

Heidorn Gerhard
Poststr. 6
87466 Oy Mittelberg
Germany
Phone: 08366-1599
Fax: 08366-9313

Ibarra Manu
15, rue de la Palla
26000 Valence
France
Phone: 04-7544030

Kosicki Gérard
Le Village
38420 Revel
France
Phone: 04-76-898447
Fax: 04/76/898504

Lindstroem Sven
Erlandstuveien 9
1178 Oslo
Norway
Phone: 02-2285417
Fax: 02-2284190

Lewis Peter
880 Salvia Street
Golden, CO 80401
U.S.A.
Phone: 0303-2710984
Fax: 0303-2711377

Magnusson Hallgrimur
Bollagata 3
107 Reykjavik
Iceland
Phone: 04-5613929
Fax: 04-5112031

Maiani Fulvio
Via Cascina Garavesa 26/9
23898 Imbersago (LC)
Italy
Phone: 039-9921539

Martin Ravel Guy
114, chemin de Galizon
38250 Villard de Lans
France
Phone: 04-76951594

Mathis Peter
Erlachstr. 45
6845 Hohenems
Austria
Phone: 05576-75083
Fax: 05576-750834

Mazuer Benjamin
266, rue de Faubourg St. Martin
75010 Paris
France
Phone & Fax: 01-40360083
Cell.Ph.: 0680/584687

Milani Marco/K3
Via della Bindellina 2/A
20155 Milano
Italy
Phone: 02-33001049
Fax: 02-33000768

Morrow Pat
P.O. Box 8118
T1W2T8 Canmore, Alberta
Canada
Phone: 0403-6782901
Fax: 0403-6785467

Moulin Nicholas
4, rue des Filles du Calvaire
75003 Paris
France

Murillo Xavier
Chemin du Truc
38660 Le Touvet
France
Phone & Fax: 04-76086004

Museo Nazionale della Montagna
"Duca degli Abruzzi" Torino
V. Giardino, 39
Monte dei Cappuccini
10131 Torino
Italy
Phone: 011-6604104
Fax: 011-6604622

Ousland Borge
Erlandstuveien 9
1178 Oslo
Norway
Phone: 02-2285417
Fax: 02-2284190

Poulet Philippe/Mission Photo
6, rue Auguste-Genin
38000 Grenoble
France
Phone & Fax: 04-76841751

Rebreyend Philippe
403, Route du Mas
38250 Lans en Vercors
France
Phone & Fax: 04-76943291

Rébuffat Gaston collection
Mme Françoise Pons Rébuffat
26, rue de Comandant Mouchotte
75014 Paris
France
Phone: 01-43207966

Rich Corey
39662 N. 86th St. W.
Leona Valley, California 93551
U.S.A.
Phone: 0209-2244194
Fax: 0209-2252219

Ridgway Rick
Granata Press Service srl
Via Vallazze, 95
20131 Milano
Italy
Phone: 02-26680702
Fax: 02-70602504

Rowell Galen/Franca Speranza
Via Melzo, 9
20129 Milano
Italy
Phone: 02-29402599
Fax: 02-29413847

Scolaris Marco/Aria
P.zza Perotti, 1
10143 Torino
Italy
Fax: 011-746744

Sheastemmikov Pavel
Risk Online
http://www.risk.ru
Liana Darenskaya - Editor
e-mail: lvd@risk.ru
Russia

Sinibaldi Livio M.
Franca Speranza srl
Via Melzo, 9
20129 Milano
Italy
Phone: 02-29402599
Fax: 02-29413847

Thornburg Jim
951, Cornell Ave.
Albany, California 94706
U.S.A.
Phone & Fax: 0510-5256293

Twight Mark F.
923, 7th Street
Boulder, CO. 80302
U.S.A.
Phone: 0303/4130830

Ulrich Thomas
c/o Adventure Photography
P.O. Box 143
3800 Interlaken
Switzerland
Phone: 033-8234708
Fax: 033-8232711

Verin Mario
Via Squadra, 5
23887 Olgiate Molgora (LC)
Italy
Phone & Fax: 039-508125
Cell.Ph.: 0338-6097911

Vincenzi Gian Domenico
Via Zabotti, 4
31056 Roncade (TV)
Italy
Phone: 0422-707535
Fax: 0422-840795

Vokhminzev Alexei
Risk Online
http://www.risk.ru
Liana Darenskaya - Editor
e-mail: lvd@risk.ru
Russia

Wagnon Patrick
L.G.G.O. BP:96
38402 St. Martin dí Heres Cedex
France
Phone: 0476-824273
Fax: 0476-824201

Wald Beth/Photography
E-mail: waldfoto@aol.com

Wiesmeier Uli/Look
Oberer Leitenweg 18
82418 Murnau
Germany.
Phone: 08841-90684
Fax: 08841-90685

Zak Heinz
6108 Scharnitz 242
Austria
Phone & Fax: 0521-35128

Zwaans Wilfried
Postbus 687
7000 AR, Doetinchem
Netherlands
Phone & Fax: 0314-360490

■ WE ARE EXTREMELY
GRATEFUL TO ALL
THE PHOTOGRAPHERS
WHO ACCEPTED
OUR INVITATION
TO COLLABORATE
ON THE
MILLENNIUM PROJECT.

THANK YOU FOR
YOUR PASSION
AND ENTHUSIASM
THAT YOU HAVE
SHOWN IN GIVING
US YOUR BEST
PHOTOGRAPHS.

■ SIAMO
ESTREMAMENTE GRATI
A TUTTI I FOTOGRAFI
CHE HANNO
ACCETTATO
IL NOSTRO INVITO
A COLLABORARE
A MILLENNIUM.

GRAZIE PER
LA PASSIONE
E L'ENTUSIASMO
CHE AVETE
DIMOSTRATO
FORNENDOCI LE
VOSTRE MIGLIORI
FOTOGRAFIE.

■ NOUS TENONS
À REMERCIER TRÈS
CHALEUREUSEMENT
TOUS LES
PHOTOGRAPHES
QUI ONT ACCEPTÉ
DE COLLABORER AU
PROJET DU MILLENIUM.

MERCI POUR
VOTRE PASSION ET
VOTRE ENTHOUSIASME
À NOUS CONFIER
CE QUE VOUS
AVEZ GRÂCE
À VOS MEILLEURS
DOCUMENTS.

■ WIR SIND ALLEN
FOTOGRAFEN
HERZLICHST DANKBAR,
DIE DIE EINLADUNG
ANGENOMMEN HABEN,
AN UNSEREM PROJEKT
"GALERIE VERTIKAL"
TEILZUNEHMEN.

WIR DANKEN
EUCH FÜR
DIE BEGEISTERUNG,
DIE IHR UNS DURCH
ZUSENDEN EURER
BESTEN FOTOS
ZUM AUSDRUCK
GEBRACHT HABT.

PRINTED IN NOVEMBER 1998

STAMPATO
NEL NOVEMBRE 1998

IMPRIMÉ EN ITALIE

ACHEVÉ D'IMPRIMER:
NOVEMBRE 1998

ERSCHIENEN
IM NOVEMBER 1998